FOR CISSY

If photography can be described as the gathering of light, then the work of Richard Ross is exemplary in the pursuit of such a goal. Whether his subject is found in museums, temples or ruins, he obsessively searches out the last ray in order that the mechanism of the camera may make tangible the very essence of the visual. His pursuit is a tireless inquiry that focuses our attention not only upon location but also upon the nature of the photograph itself—as a repository of time and memory. His strict formatting creates a taxonomy of object and place, where the frame of the picture focuses our attention upon the general and the specific, upon sameness and difference, upon the overview and the detail. However, and more profoundly, he also opens out the fermata that the photograph represents, the pause in time that is the result of the camera's gaze, and through which his works resonate with a profound and expansive silence.

Gathering Light provides us with an opportunity to explore these resonant images and the rich seam of responses that they unearth. Through their enlightening texts both Dave Hickey and Eduardo Cadava offer informed insights into the work. However, it is due to the extraordinary and tireless energy of Richard Ross himself that this book has been made possible and we wish to express our full appreciation to him.

Stephen Foster – Director, John Hansard Gallery
Julien Robson – Curator of Contemporary Art, The Speed Art Museum

gathering light

RICHARD ROSS

PUBLISHED BY THE JOHN HANSARD GALLERY, SOUTHAMPTON, ENGLAND AND THE SPEED ART MUSEUM, LOUISVILLE, KENTUCKY

DISTRIBUTED BY THE UNIVERSITY OF NEW MEXICO PRESS. 2000

INTRODUCTION BY DAVE HICKEY. ESSAY BY EDUARDO CADAVA.

introduction

DAVID HICKEY

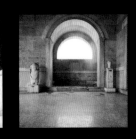

The Lightness of Primal Photography

Photography has its primal elements: the enclosure of the camera, the instantaneous flame of illumination pouring through the aperture; and it has its primal subject: that single moment of the past (which is immediately past once the shutter clicks) painted with light, so in the moment of making, the camera itself becomes a repository of the past. It has always been the virtue of Richard Ross's photographs that they speak of these primal elements and to this primal subject without devolving into formalist self-reference. Rather, Ross seeks out the physical historical precedents of photography in the world, its cultural ancestors and analogs, by turning his camera (which is a repository of the past) onto the churches, temples, museums and public spaces which are themselves repositories of the past, whose light-washed enclosures mimic the light-washed enclosures of the camera.

The effects of this agenda are subliminal enough to border on the uncanny. In his earlier photographs that portray stuffed animals in the institutional setting of natural history museums, the instantaneous stillness of the photograph overrides the stillness of the stuffed and mounted animals and uncannily revivifies them. Since we cannot tell, in the photograph, if their stillness is the product of taxidermy or photography, the animals are invested with a sense of potential life and motion that defamiliarizes the institutional setting in which we view them. A chaotic imposition of nature and culture seems on the verge of breaking out; we are reminded that life is frozen in the museum as it is frozen in the camera, which freezes us as well in a single glimpse. In his more recent pictures of religious sites, temples, churches and burial chambers, the frozen, timeless instant of the camera's blink finds its analogy in the timelessness of eternal values.

By taking light itself as the subject of his new photographs, Ross addresses the central irony of photography: the fact that photography, which lives in and by light, can no more look directly at it than ancient believers could look upon the face of God. Pure light in any photograph is a white cipher, a smear or splotch or bar of burned out nothingness. Pure light, like true love and good grammar, is one of those subjects that is only perceptible in its defect. We perceive light in its reflection, dispersion and attenuation. We recognize light on the surface where it falls, the atmosphere through which it is refracted, the enclosure it informs and the medium through which it passes. In other words, pure light is eternal; imperfect light is historical and the subject of photography. To address what is imperceptible in its pure state, Ross employs two strategies.

In photographs like Ross's portrayal of an empty room in Pompeii bisected by a diagonal of exterior light, he minimalizes and theatricalizes the central metaphor of Film Noir: the camera in the camera. By turning the enclosure of a film set into a camera lit from without through the apertures of windows and doors, Noir directors were able to photograph action being photographed from without. By eliminating the action from the enclosure, Ross emphasizes the eeriness of perceiving the camera and the room as mirrored enclosures made one in an instant of light.

In other photographs, like his portrayal of the candelabra, Semana Santa, in Seville, or his photograph of the Etruscan burial chamber lit by a double bar of fluorescent tubing, he creates essentially subjectless pictures in which the light-source blurs out into white and is only perceptible in its contextual enclosure.

In the Noir strategy, the space informed by light, mimics the enclosure of the camera, which finds its analogy in the spaciality of our consciousness. In the photographs that address the light source itself, we find a contemporary version of these Renaissance paintings in which the character and meaning of an idealized Christ is seen in reflection, in the expressions of the human follower's gaze upon him. In both cases, Ross's photographs, by engaging the primal elements of photography (and by not insisting on this engagement), demonstrate the complexity and antiquity of the traditions in which photography participates: they communicate its mysteries with bodily authority by engaging us in rituals of perception and memory that are as old as civilization itself.

gathering night

EDUARDO CADAVA

"It is not that the past casts its light on what is present or that what is present casts its light on what is past; rather, an image is that in which the Then and the Now come together into a constellation like a flash of lightning."

-Walter Benjamin

L. In each instance, the gathering of light is a story of the eye.

Each time it is a story of what the eye can see and what it cannot—of what the camera can capture and of what eludes it. To say this, however, is simply to say that our experience of these photographs is always an experience of the eye—of an eye that seeks to see where it does not see, where it no longer sees, or where it does not yet see. At every moment, we are asked to respond to a certain play of light and darkness—the light and darkness without which the eye would have no story— and we respond to the muteness of this play by inventing stories, by relating each of these shifting images to several possible narratives.

We will never know, however, if the stories we tell—about what we think we see as we look—will ever touch or engage the images before us. This is why these stories should not be understood as a commentary: in the end, they will tell us nothing. If the story of these images cannot be told (especially since it is questioned again by each new image), what our stories and words say may bear no relation to the photographs that hold us and fascinate us. Nevertheless, the power of these photographs lies in their singular capacity to give us a photographic description of a history of photography. In each case, the photograph is a photograph about photography. But what happens when, as is so often the case in these images, a photograph gives the experience of the eye over to blindness, when it leads the line of our sight toward a light or shadow that prevents us from seeing? What happens when our eyes meet what they cannot see, or when they encounter what cannot be encountered? What might this experience of blindness and shadows have to do with what makes photography photography? In what way do these images tell us that sight—what we might call the "gathering of light"—is

essentially linked to an experience of mourning, an experience of mourning that mourns not only experience but sight and light themselves?

As the works of Richard Ross would have it, from the moment a technology of the image exists, these questions tell us that sight has always been touched by the night. Whether we are asked to view the interiors of museums or tombs, the hidden recesses of ruins or churches, the inner chambers of temples or long-forgotten prisons, or the many other dimly lit enclosures or spaces that punctuate and compose this sequence of images, sight is shown to be inscribed in a body whose secrets belong to the night. It radiates a light of the night. It tells us that the night falls on us—and perhaps falls on us most when light is at its brightest intensity, when its brightness blinds us. Even if it were not to fall on us, however, we are already in the night as soon as we are captured by optical technologies that have no need for the light of day. In the nocturnal space in which the image that we are about to seize is produced, it is already night. This is why these photographs exhibit a light that never arrives alone. It is always attended by darkness. We might even say, following Ross, that the relay between light and darkness that characterizes photography also gives birth to it. Luminosity emerges in these images from out of the coincidence of light and dark, of day and night—from the play of light and shadows that touches and shapes our everyday existence. Suggesting that there is no moment of illumination that is not also a moment of darkness, these photographs tell us that it is only when light is no longer light, no longer simply light, that it becomes light. A light that does not break with night or darkness, photography can be said to occur when a moment of illumination refuses to remain self-identical to itself.

If these photographs stand as a kind of homage to light, it is because they also celebrate darkness—a darkness without which light could never be experienced. If they take light as their theme, it is because this theme is shown to be indissociable from that of darkness. Or, to cast a more precise light on the matter, if the theme of these photographs is light, it is light as what withdraws from theme, as what cannot be thematized.

This is why, as soon as it takes place, the photograph, consenting to its own disappearance, vanishes—and, in vanishing, it tells us that it never appears without its shadows, without its hidden features, without the night to which it always returns. **In each instance, then, the gathering of light is also a gathering of night.**

I. In each instance, the gathering of light is a gathering of time and history.
What would it mean to assume responsibility for an image or a history? How can we respond to the history inscribed within this particular image, for example? Every detail of the photograph has its force, its logic, its singular place—the diagonal stream of light that nearly tears the image in two, the ruined walls covered with the remains of several ancient frescoes, and the room itself, which resembles nothing more than the inside of a strange camera obscura. A condensation of several fragmented histories and images, the photograph—like all of Ross's photographs—nevertheless remains linked to an absolutely singular event, and

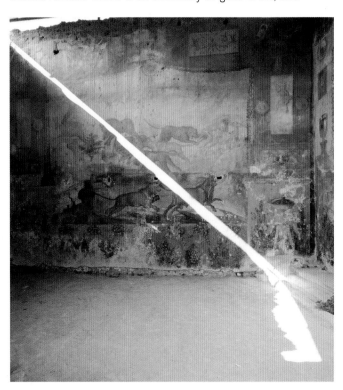

therefore also to a date and site, to an historical inscription. And yet, because of the process whereby it was produced—most of the photographs here were created by leaving the shutter of the camera open for relatively long periods of time—the image also absorbs and bears the traces of a passage of time. Opening a space for time itself, dispersing it from its continuous present, the image registers the relay between the past and the present that also defines the site in which it was produced: one of the many ruined chambers of Pompeii.

But how are we to read this image? How can we respond to the history commemorated, displaced, and ciphered by this photograph—a history that includes not only the history of the destruction and preservation of Pompeii, but also, as a kind of secret, the history of photography itself? How, in a perversion of temporality made possible by Ross's extraordinary photograph, can the history of Pompeii tell us something about the essence and history of photography? The photograph begins to cast an interpretive light on these questions and, in so doing, goes very far in suggesting what a photograph is, what it can and cannot accomplish.

We need only recall the most significant details of the Pompeii story—a story whose details are partially reproduced on the walls of the room displayed in the image. Built on the shores of the Bay of Naples—on an area of prehistoric lava flow called the "burnt fields"—Pompeii was raised on the site of the fabled battle between the Giants and the Gods, in which the Giants were cast down and destroyed by Zeus's thunderbolts. A site whose history is entangled with that of fire and light—and of a light that, cast down from the heavens, left its flashing and burning signature in the land as a kind of memorial—Pompeii could be said to have been born on the soil of photography: or, perhaps more precisely, to have been one of the several birthplaces of photography. The photographic dimension of Pompeii's history—a history traversed by the play of light and darkness that defines the photographic space—becomes even more palpable as we remember that, when Vesuvius erupted in August 79AD, the city was buried in volcanic debris and ash. The ash and fire that burst forth during the violent eruption of Vesuvius was said to have overshadowed

the air and, like an eclipse, to have hidden the sun. Contemporary accounts tell us that the day turned into night and light was transformed into darkness. "Clouds of fearful blackness overtook the skies, pierced through and through with flashes of lightning," writes Pliny the Younger (our chief sources of information on this event are the two letters that he wrote to Tacitus), and "it became dark, not as on a cloudy night when there is no moon, but as in a room which has been completely closed." Transforming the entire landscape into a gigantic dark room, the cinders that came forth from the eruption of Vesuvius worked to both destroy and preserve this city that, becoming in its own cataclysmic turn a kind of museum, to this day still bears the traces of this massive photographic event. Like the photograph that is so often said to be a force of destruction and preservation, the ashes of Vesuvius became a means of forgetting and remembering the death and ruin that took place within Pompeii's walls.

If the history of the memorialization of Pompeii can be shown to belong to the history of photography, Ross's image has much more to say about the nature of photography in general—and, in particular, about the role and place of light within photography. Presenting itself as a kind of camera obscura, in which a narrow and irregular horizontal opening permits a narrow streak of diagonal light to both produce and sear the image, this ancient room has inscribed within its walls the work of earlier modes of reproduction—frescoes, murals, stone and wall paintings—that, together, reveal the colors and ruins of a past. Like the ruined city to which it belongs, the room is also a museum, but a museum of different media of technological reproduction.

This is why, we might say, the diagonal ray that transforms the room into a camera obscura is a very strange light. If it is the very condition of the image—what makes the image possible—it at the same time pierces through the surface of the photograph. It cuts through it. It interrupts and erases whatever lies in its path. Exposing the photograph to the possibility of its disappearance, the light exposes it to ruin, to damage, to annihilation. This ruin in the photograph corresponds to an interruption of the presentation of history. Or, to put it another way, the disintegration of presentation produced by light exposes a caesura, a ruin in

the presentation of historical experience. This ruin indicates a space in which the photograph does not mean, does not designate anything. Like the "shape all light" that appears in Percy Shelley's last and unfinished poem, "The Triumph of Life," this ruin composed of light is referentially meaningless, since light, the necessary condition of shape, is itself without shape. If it is time that ruins the photograph, however—we should remember that this ray of light exists in the image because of time, because of the exposure time of Ross's camera—this ruined photograph interrupts the movement of time, in a manner that has, not the form of time, but rather the form of time's interruption, the form of a pause, of a wound. This ruined photograph wounds the form of time. It suspends and deranges time. But since time—and all time—can be deranged in this way, the time inscribed in this image perhaps names a kind of madness. And this madness is nothing else than the madness of light.

Light is mad, and its delirium and danger are legible in this image: the image tells us that whatever is illumined by the punctual intensity of this light—the emergence of the image, for example—can at the same time be burned, incinerated, consumed in flames. This is why, when this mad light hits the floor of the room, it turns and scatters. It begins to transform into a shape that, seeming to move in the direction of the wall that first let it in, not only resembles a flow of lava but also turns the floor into an opposing flow of brownish-gray lava. Evoking in this way the history of fire and light that made Pompeii what it is, this gathered light comes to us as a force of separation, division, and violence. Burning into the image, it recalls the Vesuvian fire and ash that destroyed and preserved this ruined chamber. A luminosity that erases as much as it shows, that blinds as much as it enlightens, that separates as much as it gathers, this delirious light tells us that photography involves the burning of its contents. This is why, in accordance with the law and structure of this photograph—and to the extent that its light represents, if it represents anything, a kind of burned-out emptiness—every photograph in this exhibit is touched by this white or blank light. This link between the blank space of the image and the white that composes it means that every "white" or "blank" in these photographs is a trope for the

"empty" white space we "see" in this lighted image (and vice versa)—from the innumerable windows or doors of light that we find throughout these photographs to the streams of light that enter the Church of Jesus Nazareth in Mexico or the Iglesia de San Luis Sevilla in Spain, from the light that falls into the San Juan de Ulva Fortaleza in Veracruz or the abandoned Eastern State Penitentiary in Philadelphia to the lighted billboard in Filmore, California, from the light that casts its rays into the temples or museums that appear throughout these images to the white bodies of the swans in Booth's Bird Museum to the needle of light that pierces the Blane Kern float. In each instance, the more Ross's camera tries to capture and gather light, to harvest it in all its glory and beauty, the more this light tears or sears the image, the more it interrupts it, the more it reduces it to ashes. In this way, Ross's photographs tell us that, without interrupting the historical continuum, without blasting the techniques of representation, there can be no historical time. No history without the interruption of history. No time without the interruption of time. No photograph without the interruption of the photograph. Taking our point of departure from this image of Pompeii, we could even say that the truth of photography lies in the relation it stages between light and ash. As Man Ray wrote in 1934, in an essay entitled "The Age of Light," images are always only the residues of an experience. This is why what we "see" in an image is what has "survived an experience tragically, [what recalls] the event more or less clearly, like the undisturbed ashes of an object consumed by flames."

In each instance, the gathering of light is an interruption of time and history.

G. In each instance, the gathering of light is a work of preservation and destruction.

The whirlwind of metaphors unleashed by photography since its historical appearance revolves with conspicuous constancy around several motifs: among others, technology, memory, forgetting, reproduction, mimesis, death, mourning, and language. With equal constancy, this proliferation of metaphors bears witness to the fact that photography appears to elude strict definition.

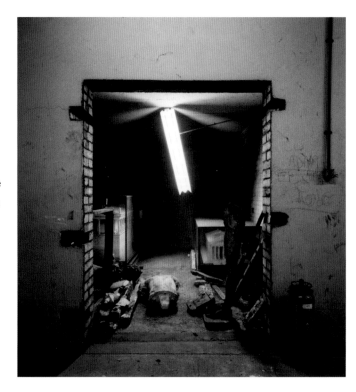

It is no accident, however, that the photograph often has been associated with the work of the museum, nor is it by chance that the museum has held a permanent interest for Ross. Indeed, throughout his work, the museum has been a privileged means for exploring the nature of photography. Like the photograph, the museum is a means of preservation and recollection, a means of recording and telling history. As such, it, too, has been likened to a mausoleum, a memorial, a cemetery. At the same time—and this is suggested by this photograph of one of the storage rooms at the British Museum—it is also a kind of storehouse, an archive of neglected or abandoned cultural treasures, of what has been pulled from circulation, forgotten or left behind. The museum therefore has the double function of conservation and transformation: it works to conserve traditions even as it destroys them through a process of decontextualization. This is why, like the photograph, the museum can be said to be organized around loss: like the photograph that isolates a particular historical moment, that tears an event, an object or person out of the contexts in which they exist, the museum begins with the loss of

context or function that every item in its collections must undergo. Nevertheless, if what is exhibited is torn out of the context in which it was produced, if it must be torn out in order to be exhibited, then we can understand the museum as a site of recontextualization, and the orphaning on which it depends as the giving of new life.

The relays between museums and photographs are reinforced by the image, since the lens and framing of the photograph are placed en abîme: like the Pompeii photograph, this image also transforms its contents into a photographic space—into a space devoted to reproductions, the relays between light and darkness, and the intersection of memory and forgetting. Indeed, the several enclosures in the image can each be said to be a metaphor for the inside of a camera. Among so many other things, they evoke a series of camera-like chambers—the outer room or hallway, the inner, barely lit room, the glass encasements—that work together to allegorize photographic desire, even as they interrupt it.

A kind of tomb or burial chamber for the shattered remains of a past, the room stores a seemingly random collection of fragments, replicas, and glass cases. What links them to each other, though, is that each one belongs to a particular mode of reproduction: the entryway presented as an oversized aperture through which we can view the inside of this dimly lit space, the fragmented torso strewn across the floor, the amputated leg standing on a pedestal (itself a kind of pedestal), and echoed by the pedestal on the other side of the room, by the columns that form part of the encased replicas, and by the hanging limb of light, whose barely visible lines seem like so many tendons. What is extraordinary about the image is the way in which each enclosure seems to absorb what it reproduces—we need only notice the way in which the glass enclosures bear their Greek replicas within them—as if the work of the camera were to reproduce what it photographed within its light-washed walls.

Nevertheless, torn from the contexts that would give them meaning, these fragmented abstracts of anamnesis are unable to gather contextual or historical meaning. They remain signs, and present themselves as such. But they form no historical record and give no coherent image of the past. Illuminated by the declining, falling light of the present—a light that, on the verge of falling without yet having fallen, anticipates the moment when, falling from the ceiling, it will fall and shatter across the room and floor, will return, in all its fragments, to the darkness from which it emerged—these scattered remains evoke the fragmented and partial memories given to us by photography. The photograph lures us into its world, invites us to pass through the room's threshold, in order to display its capacity to preserve the broken pieces of the past, but also to suggest the ways in which these memories are held in reserve, sometimes put away and forgotten until, one day, we happen upon them, and view them under the falling and failing light of our own eyes—or, to be more precise, amidst the shadows and recesses of our memory's eye. Drawing us into its space, the photograph tells us that, in order to see it from the outside, we must already—or still—be in the photograph. In order to bring the truth about the photograph to light, we must be ready, as Ross always is, to bring it into the light of the photograph. To say this, however, is to say that we can only speak about the photograph from its threshold. And the photograph is itself perhaps nothing other than a threshold, an opening and a closing—simultaneously a greeting and a farewell. **In each instance, the gathering of light shatters what it seeks to remember.**

H. In each instance, the gathering of light is a force of petrification.

In Rainer Maria Rilke's poem, "The Blind," a blind woman speaks of her "eyes walled up." These leaden walls are said to enclose her inside the night of a kind of tomb or prison. Exiled from light, she is condemned to exist as one of the living-dead. Her body transformed into a kind of sepulchre, she endures her existence behind the walls of her eyes—within an interior prison more restrictive than any literal prison of stone. If we were to attempt to represent this woman, her specular isolation—her isolation from sight—would seem to call for an image commensurate with her insularity. Whether or not Ross knows this poem, I would like to suggest that this image of a kneeling, praying woman—taken in one of the inner chambers of the Church of the Holy Sepulchre

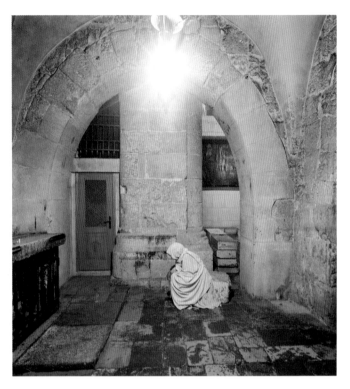

in Jerusalem, a city whose privileged relation to light, divine or otherwise, is well known—responds, in however a displaced and distorted manner, to this blind woman's call to be represented. Evoking several figures of light, darkness, blindness, imprisonment, petrification, and death, the image also transforms this enclosed space into a fable about photography.

What is perhaps most striking about the image is the way in which, once our eyes enter it, they cannot escape. Everything about the image is closed and sealed. Even though the door at the left of the image remains closed, if it were not for its existence—and its silent promise of escape—the image would be almost unbearable in its claustrophobic effect. Everything seems to be absorbed into this stone enclosure. The woman herself looks frozen in her kneeling position—surrounded by stone, enclosed by stone, wearing her praying shroud as a statue would wear its marble or plaster clothing draped over its body. This petrification is confirmed—we might even say set in stone— by the way in which the lower end of her shroud is slowly being transformed into the stone that surrounds it. Moreover, positioned

as she is in the middle of the column that seems to divide the stone arch in two, the curve of her back mimes the shape of the arch's right half—in this way reinforcing the identification between the woman and the stone around her. The only visible part of her body—the only remnant of flesh—is her right hand. But the hand, too—as if it already were made of stone or wood—not only shares the brownish-red color of several of the floor tiles before her but also the color of the door. In addition, the contour of the hand seems to finish the arch begun by the shape of the woman's back and therefore mimes the left half of the stone arch that frames her. The pervasiveness—and inescapability—of the stone in this image becomes even more tangible when we note how the rectangular shape of the stone is repeated throughout the image: in the stones that compose the floor, the column, the arch, and the walls, and even in the mesh-grille of the door and the barred space above it.

The only possible break in this enclosure is provided by the light that shines above the woman's figure—the light that makes this image of petrification possible, but also the light that seems to burst forth and break through the bulb or fixture that would contain it. This burst of light, flashing above the image like the flash of a camera, evokes the divine light toward which the figure's prayer is supposedly directed. Although the woman's eyes are turned away from this light—signaling her humility as well as her inability to look at the light directly—unlike Perseus, who deflects the gaze of Medusa in order to elude his petrification, she is unable to prevent her transformation into stone. Like the camera's flash, this light is a force of arrest and petrification— and therefore of history. Indeed, as Walter Benjamin would have it, there can be no history without the Medusa effect, without the capacity to arrest or immobilize historical movement, to isolate the detail of an event from the continuum of history. This immobilization, this petrified objectivity, makes it impossible to distinguish between life and death (something that is confirmed by all of Ross's photographs, but especially by the several photographs he has taken of dioramas in museums of natural history, in which it is impossible to decide whether or not the hippos, giraffes, swans, deer, lions, or polar bears in them are alive or dead).

Still, as if in response to the prayer that seeks to penetrate the walls of the room in order to find the heavens, the light bursts through the image and figures, among other things, the rays of a star (scarcely an innocent figure in Jerusalem), the excess of divine light, and, as if unleashing or opening the curved hand of the woman, the opened fingers of God's light. The light therefore signals a site of passage, a kind of threshold through which the woman's prayer, following the photographic path of a via negativa, might gain access to another light—not the "more than luminous darkness of silence" of which Dionysus wrote in his negative theology (and which, according to him, so often attends the silence and solitude of prayer), but rather a light that is beyond the artificial light that makes this image possible. We could say, however, that this other light, a light that is heterogeneous to the realm of the visible, nevertheless haunts the image in its very possibility. This is because the visibility of the image, what makes the image visible, can, by definition, never be seen. The beauty and force of this particular image lies in its fidelity to this truth. It tells us that the world of the photograph is a world composed of light, but of light that can never be gathered or brought under our gaze. In this world, we can see, but only as this kneeling, praying woman sees—that is, only by turning away from the light that casts its rays on our existence, only by closing our eyes, only by living and dying within the walls of our eyes. **In each instance, the gathering of light names the blindness that gives birth to sight.**

T**.** **In each instance, the gathering of light never takes place.**

If Ross's work can be said to be organized around what remains inaccessible to sight—even if, like all photographic work, it, too, seeks to make the invisible visible—this withholding and with-drawing structure prevents us from experiencing it in its entirety. It encourages us to recognize that these photographs, bearing as they do several memories and histories at once, are never closed. The altering borders of the images are permeable and open, which is why the three images on which I have focused open onto stories that can be told or revised, here and there, each

time we turn our eyes toward them. If these images evoke a moment of crisis and destruction, part of what is placed in crisis is the finitude of the context within which we might read them. They belong to a process of transformation whereby the image, changing in response to the movement of light that traverses and pierces it, caresses and touches it, withdraws from itself in order to mark its changing relation to several futures. This means that Ross's art can never be made. It is rather the "making," the multiplicitous tracing of the memories and histories within which each of these images take place—memories and histories that belong to his ongoing story about light. The borders of such work are incessantly multiple and suspended. This is why the shifting traces of light and shadow, of day and night, that compose and haunt these images are at once the always changing limits of the work and the work itself.

In each instance, the gathering of light is never finished.

"One must live in the middle of contradiction because if all contradiction were eliminated at once life would collapse. There are simply no answers to some of the great pressing questions. You continue to live them out, making your life a worthy expression of leaning into the light."

BARRY LOPEZ. ARCTIC DREAMS. IMAGINATION AND DESIRE IN A NORTHERN LANDSCAPE

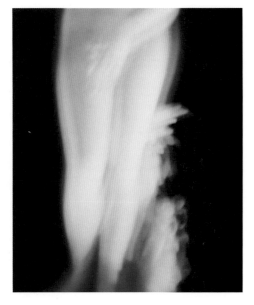

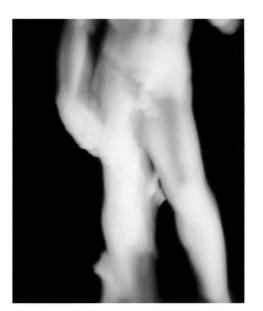

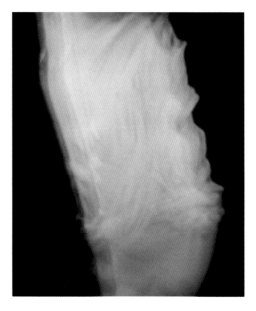

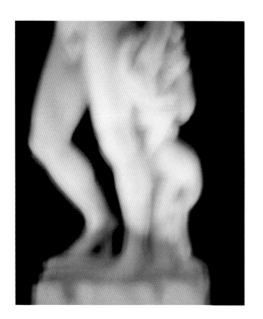

CAESARS PALACE, LAS VEGAS NEVADA 1987

CAESARS PALACE, LAS VEGAS NEVADA 1987

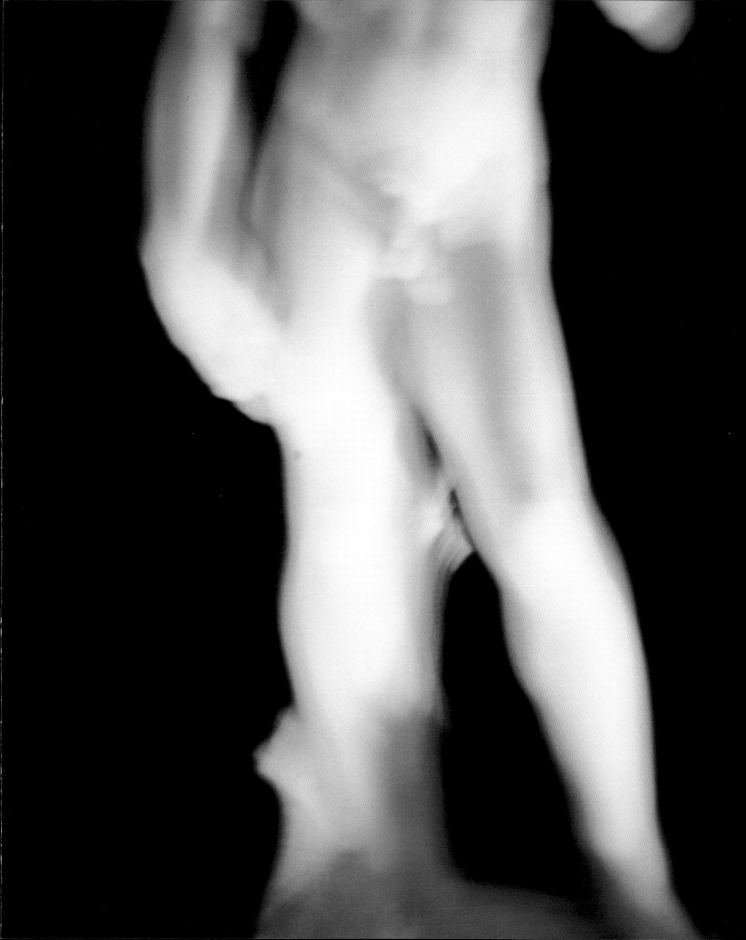

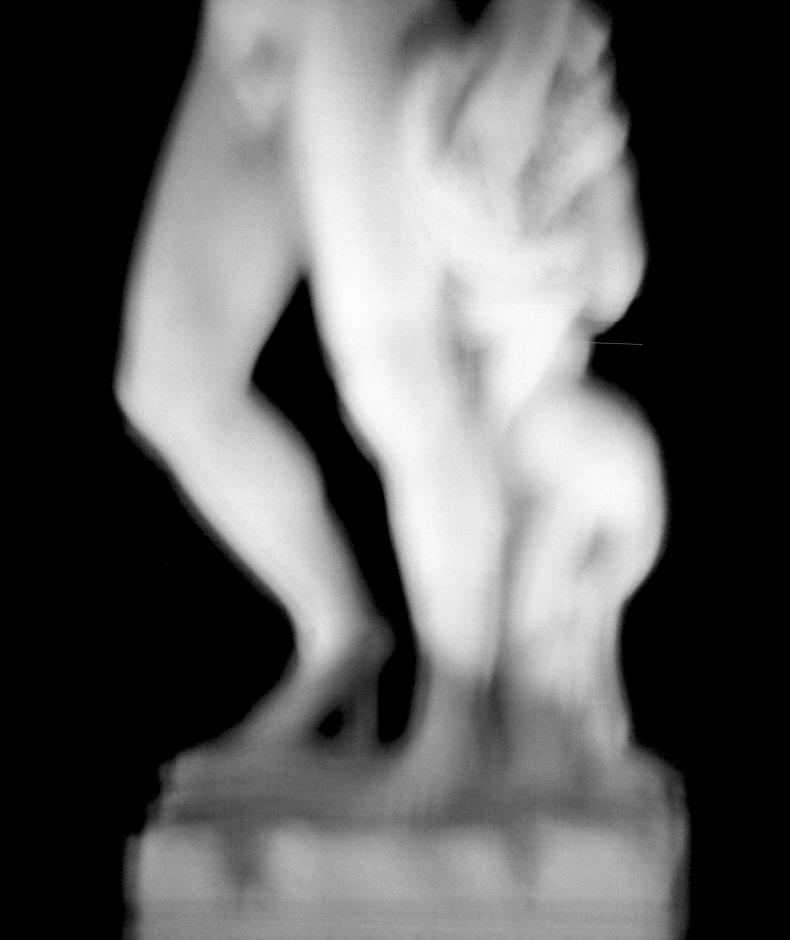

"There is no object so foul that intense light will not make beautiful."

RALPH WALDO EMERSON. NATURE

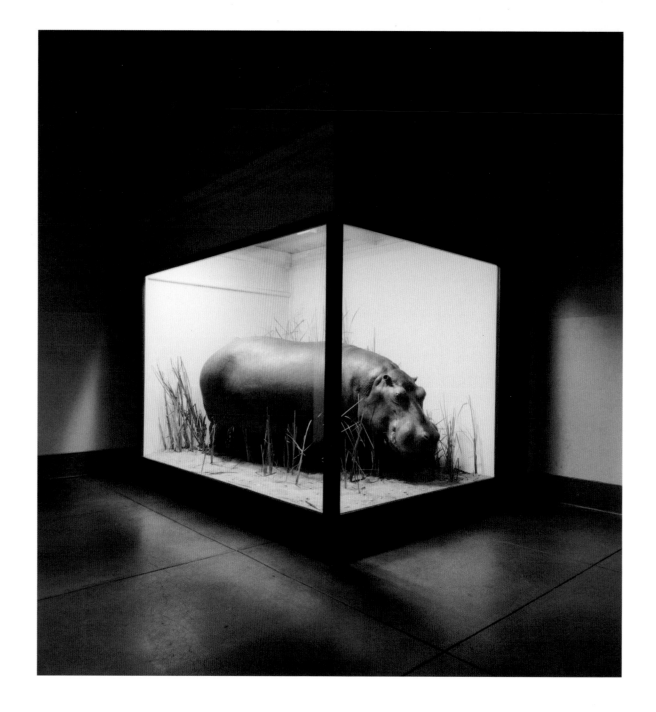

FIELD MUSEUM, CHICAGO, ILLINOIS 1986

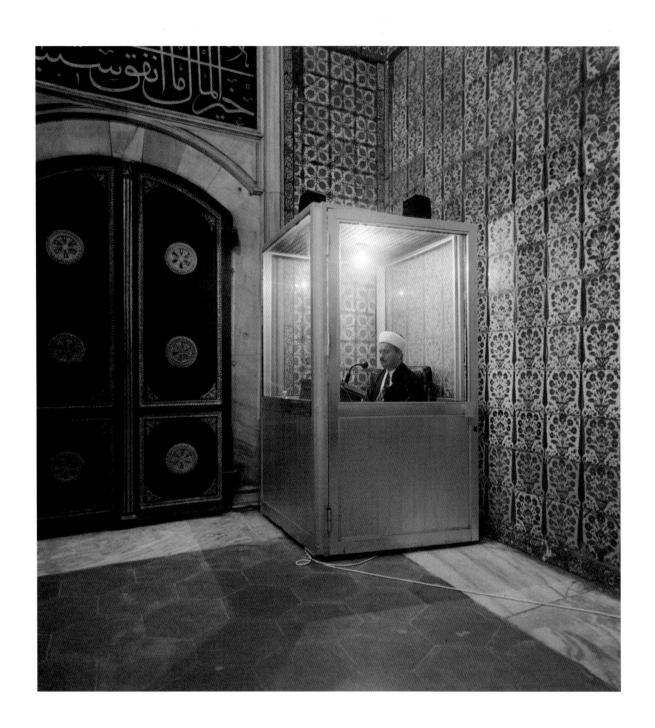

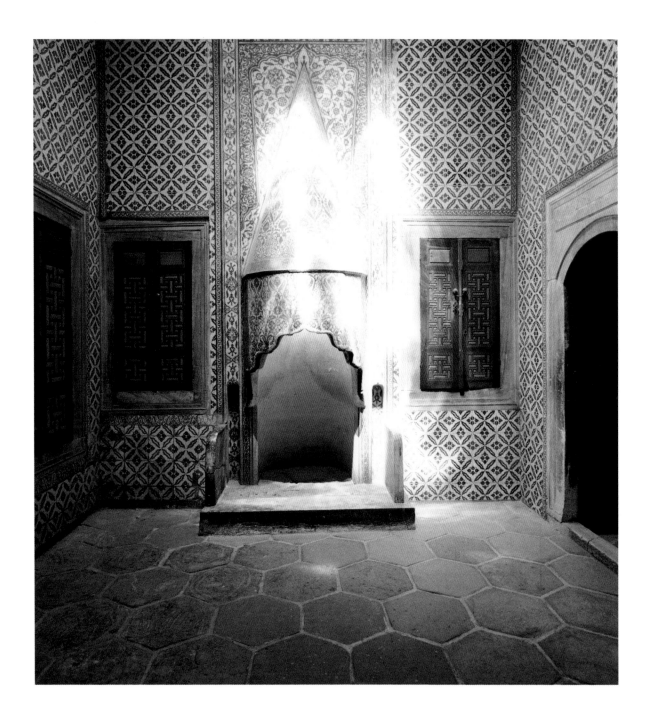

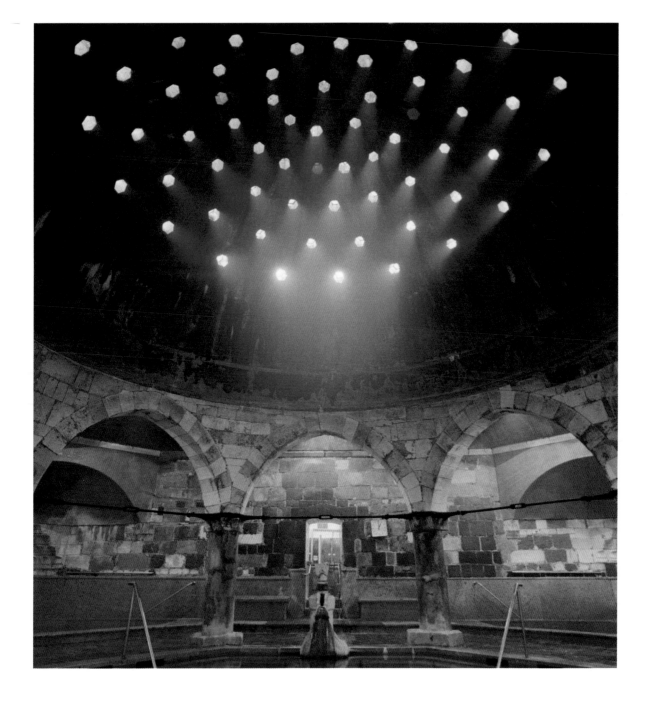

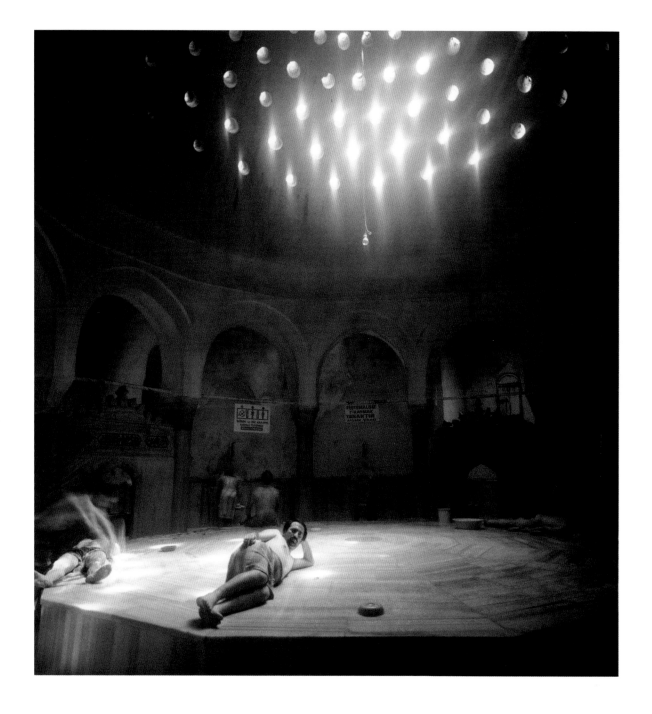

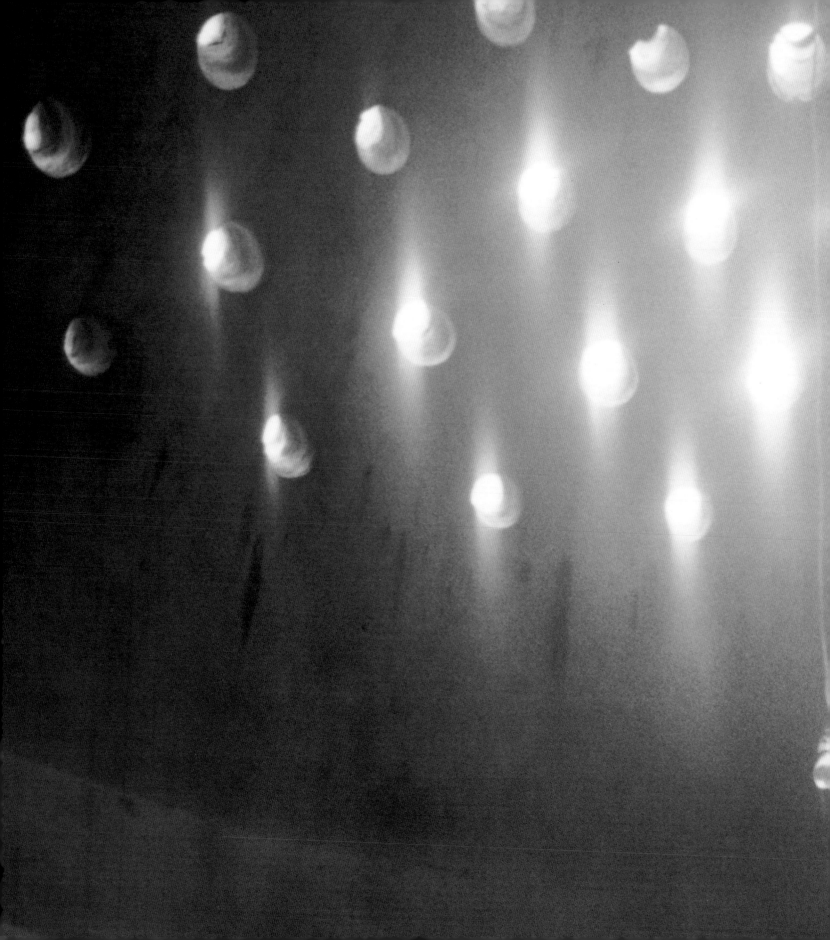

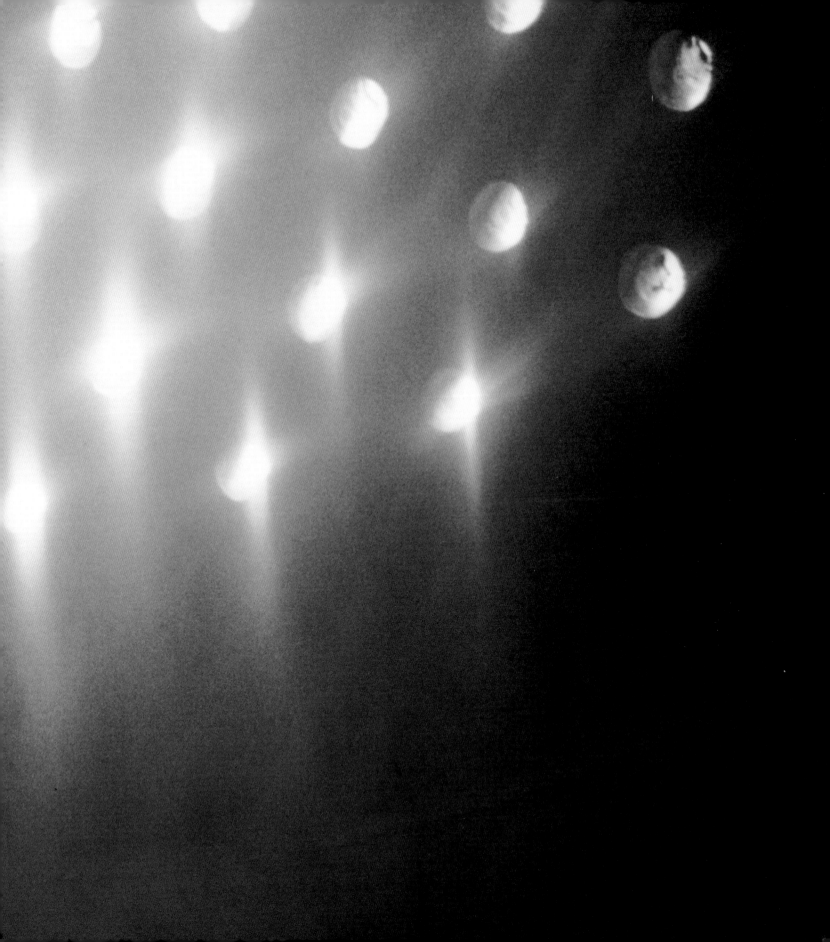

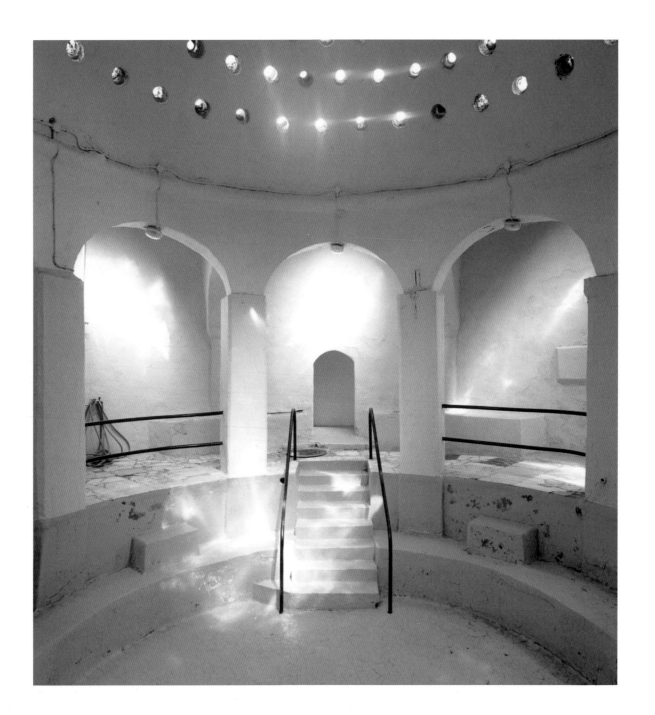

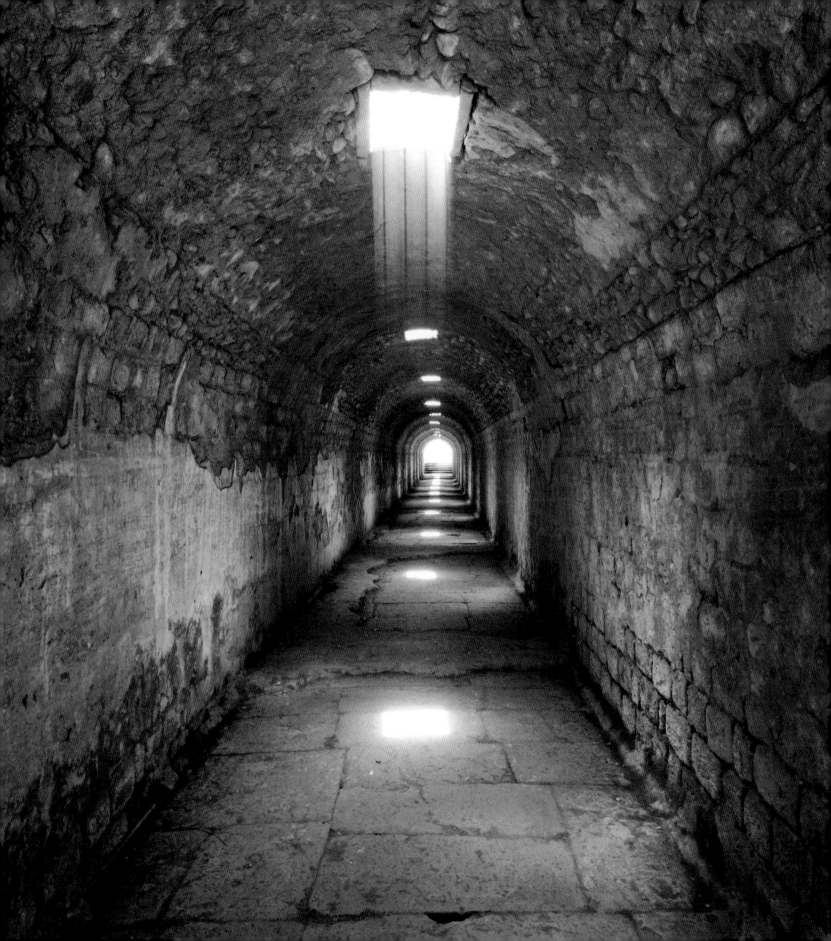

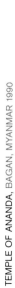

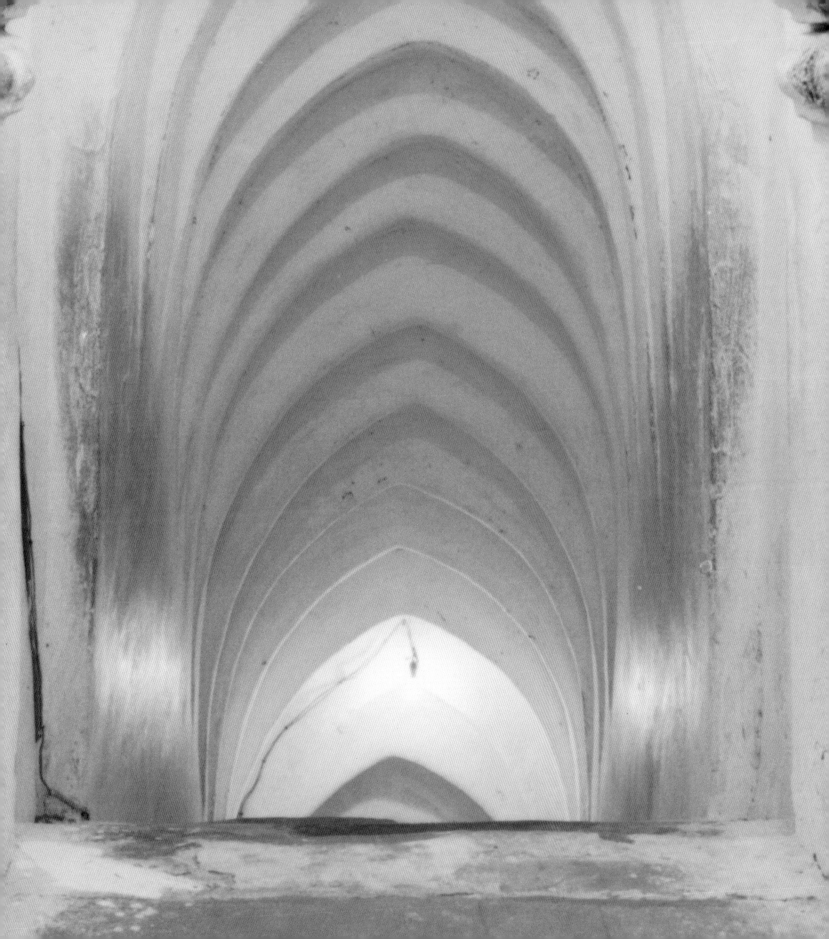

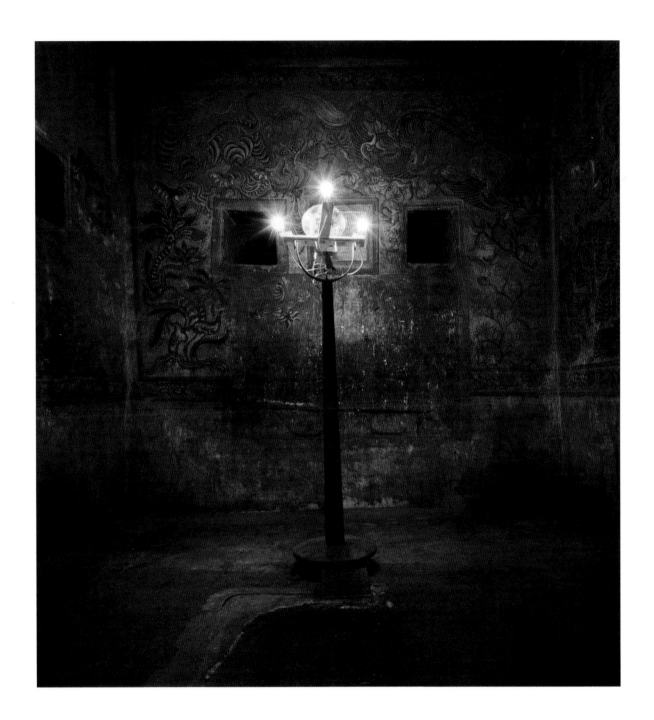

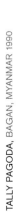

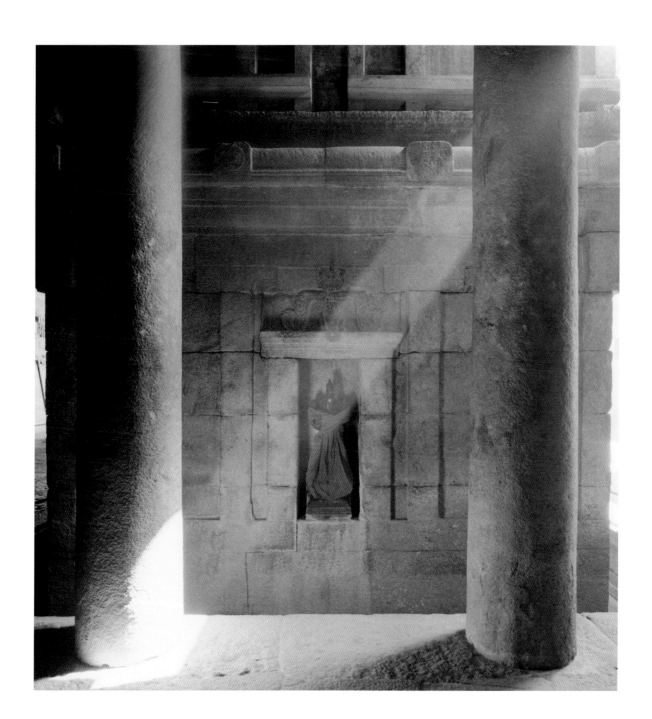

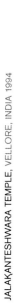

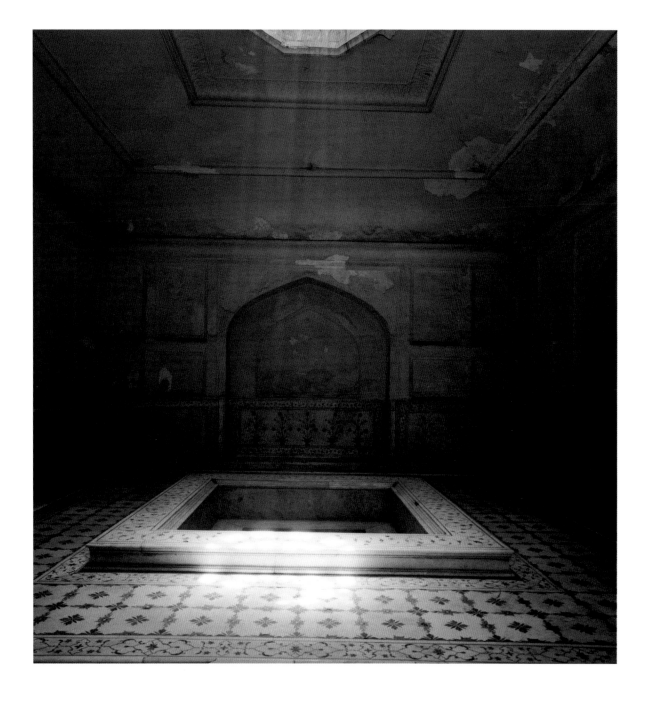

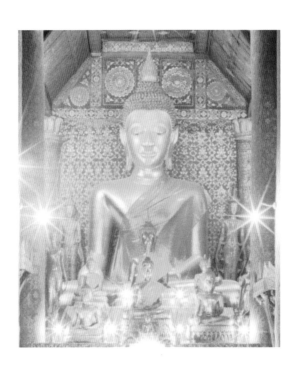

WAT XIENG THONG, LUANG PHABANG, LAOS 1995

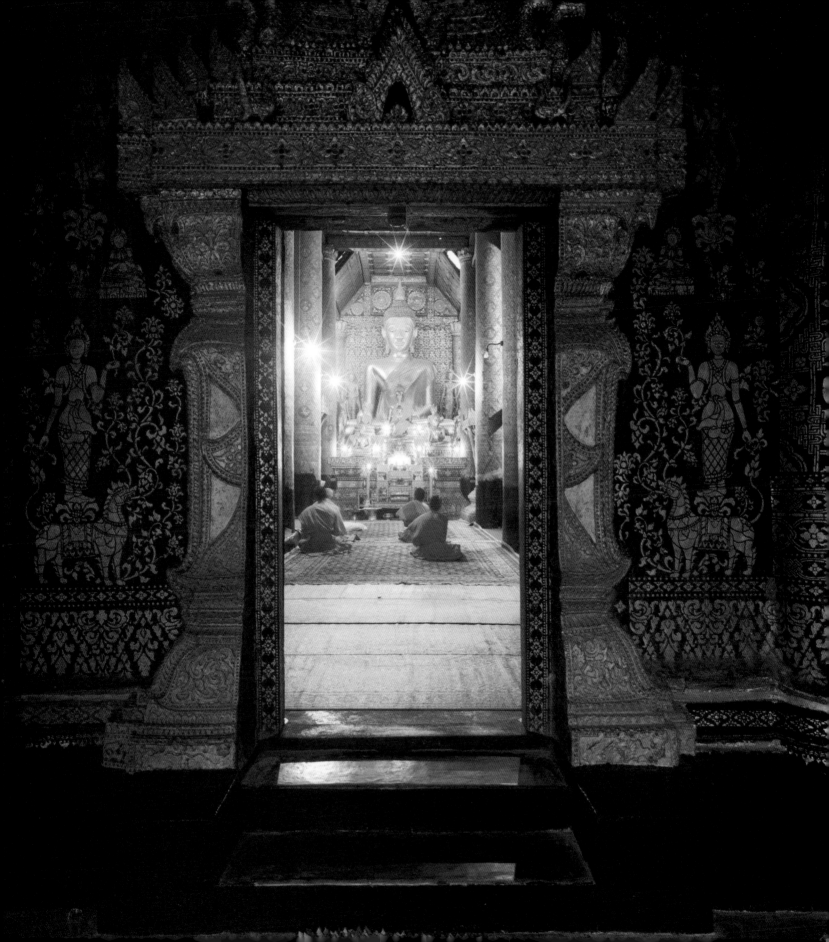

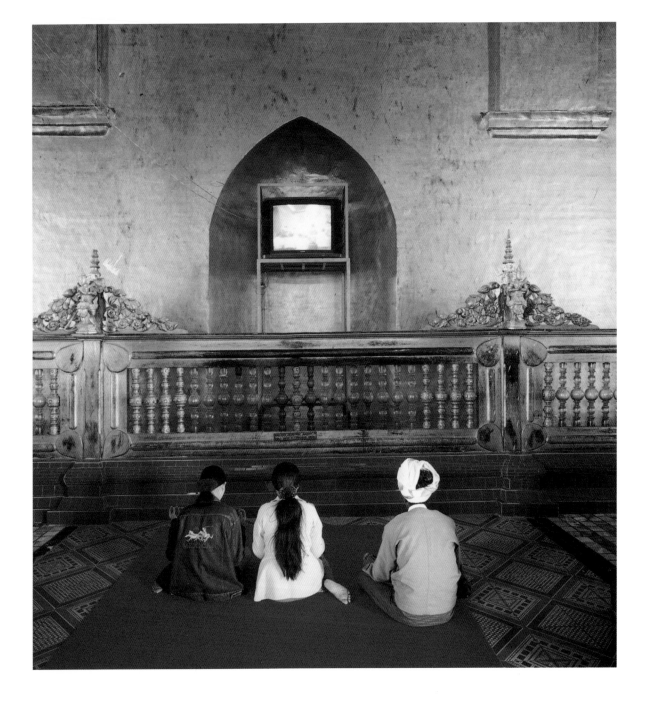

MAHAMUNI PAGODA, MANDALAY, MYANMAR 1995

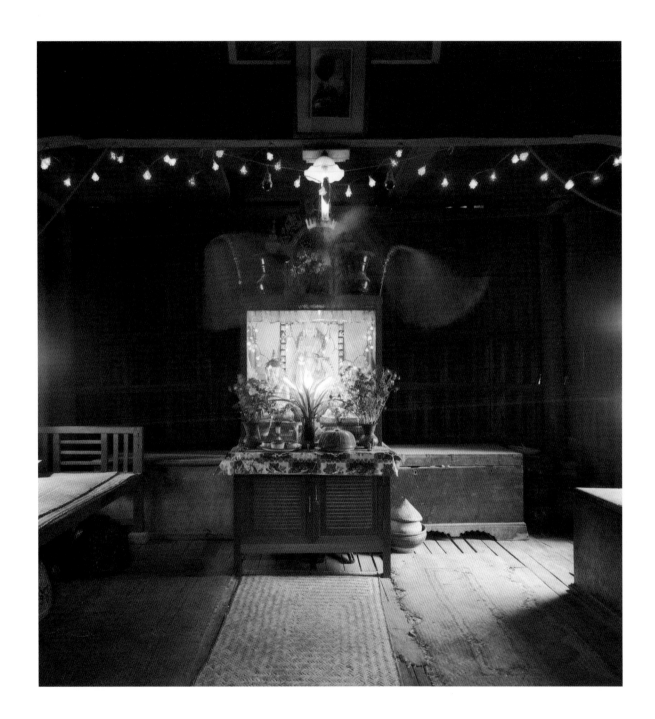

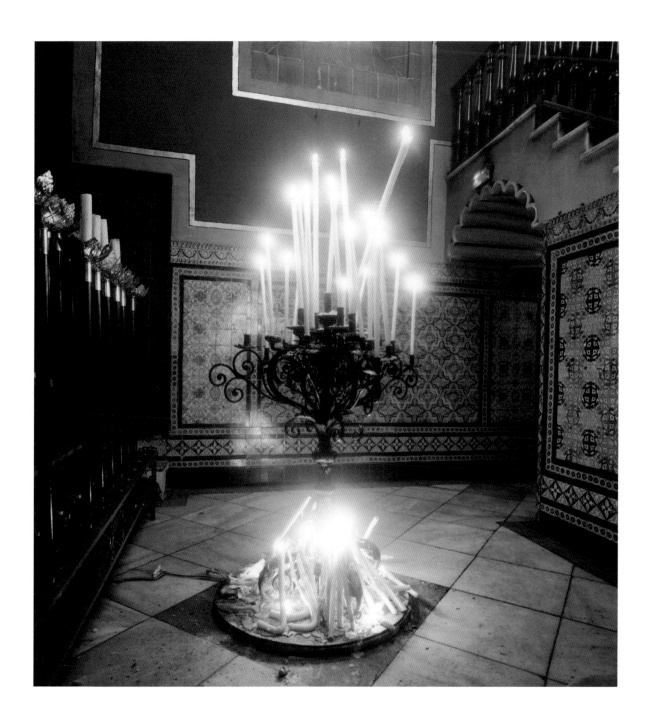

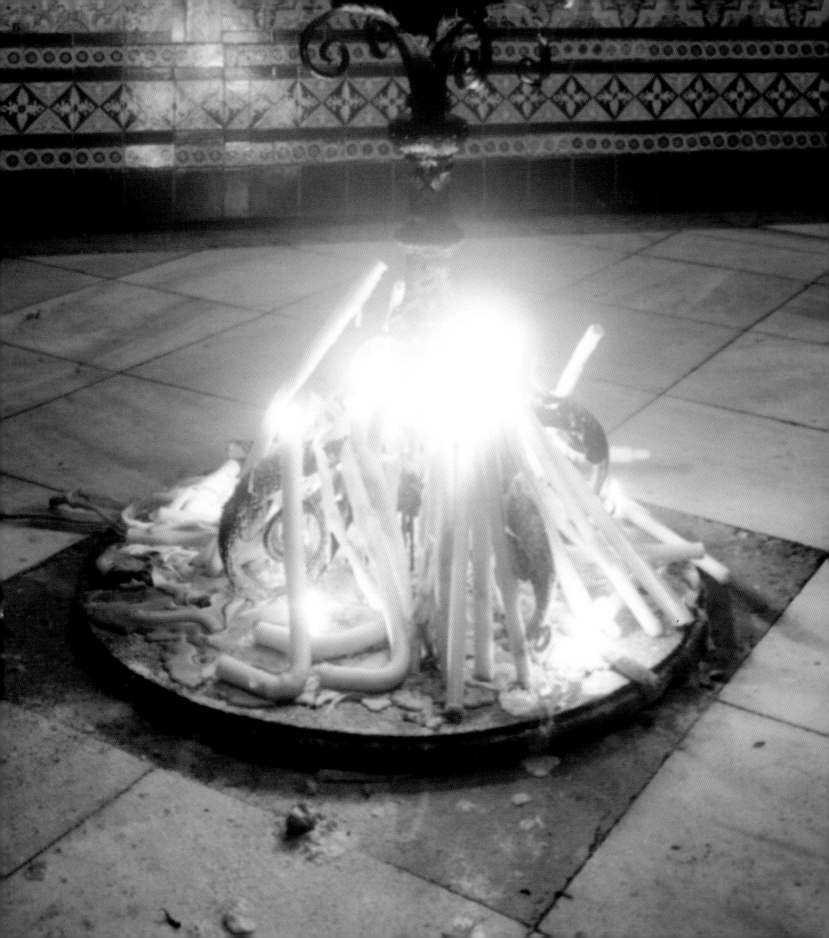

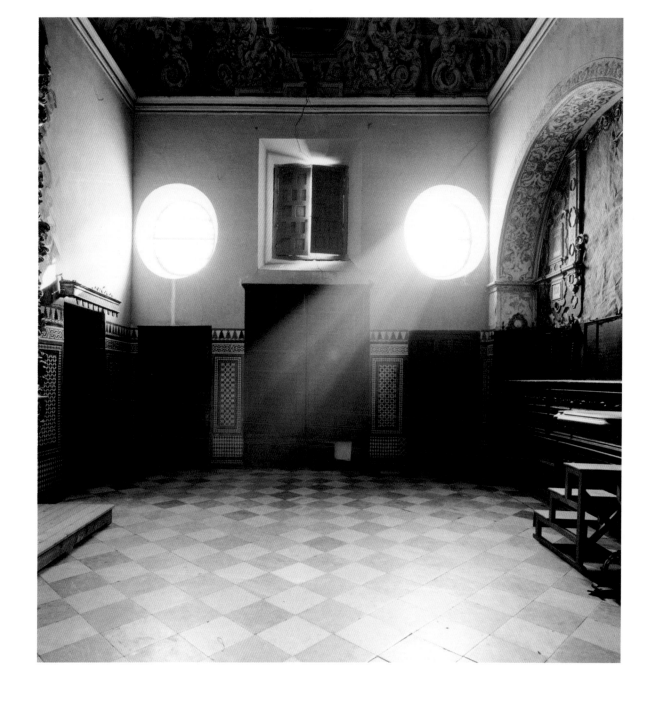

IGLESIA DE SAN LUIS, SEVILLE, SPAIN 1993

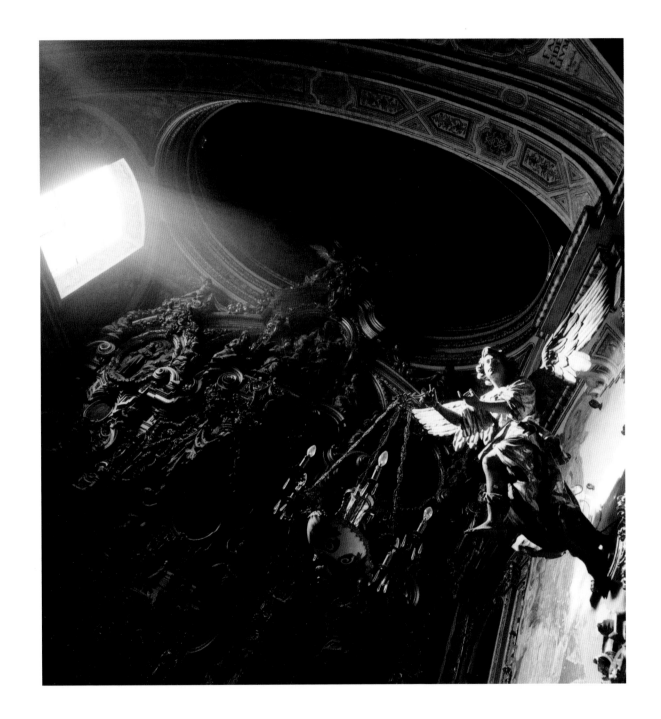

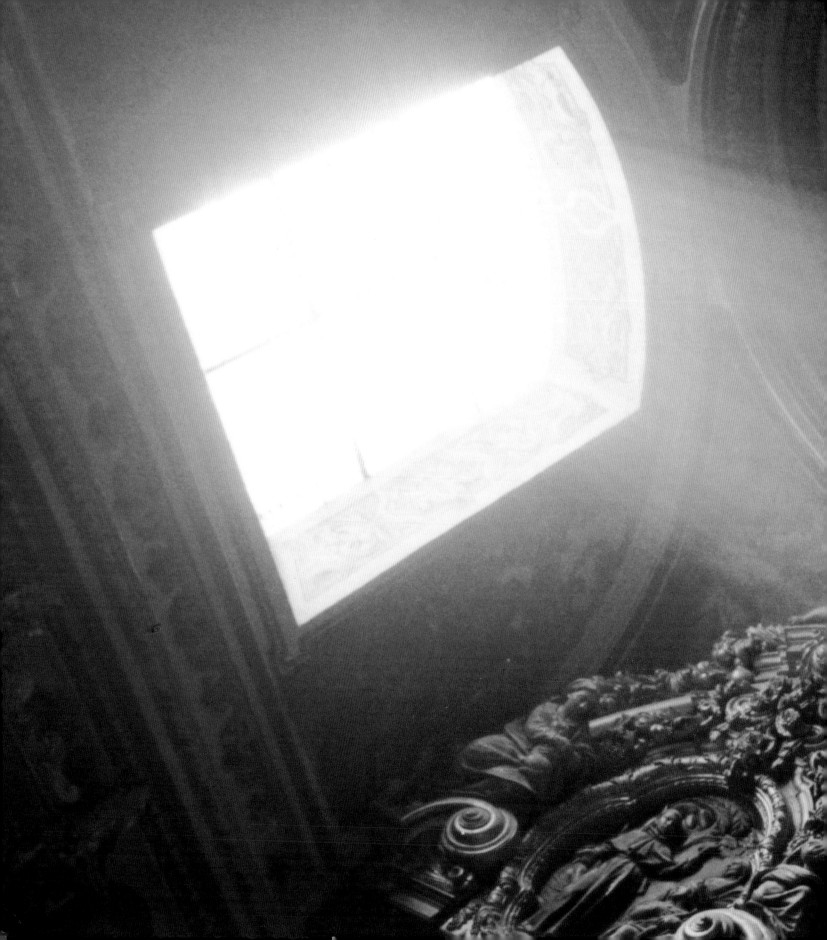

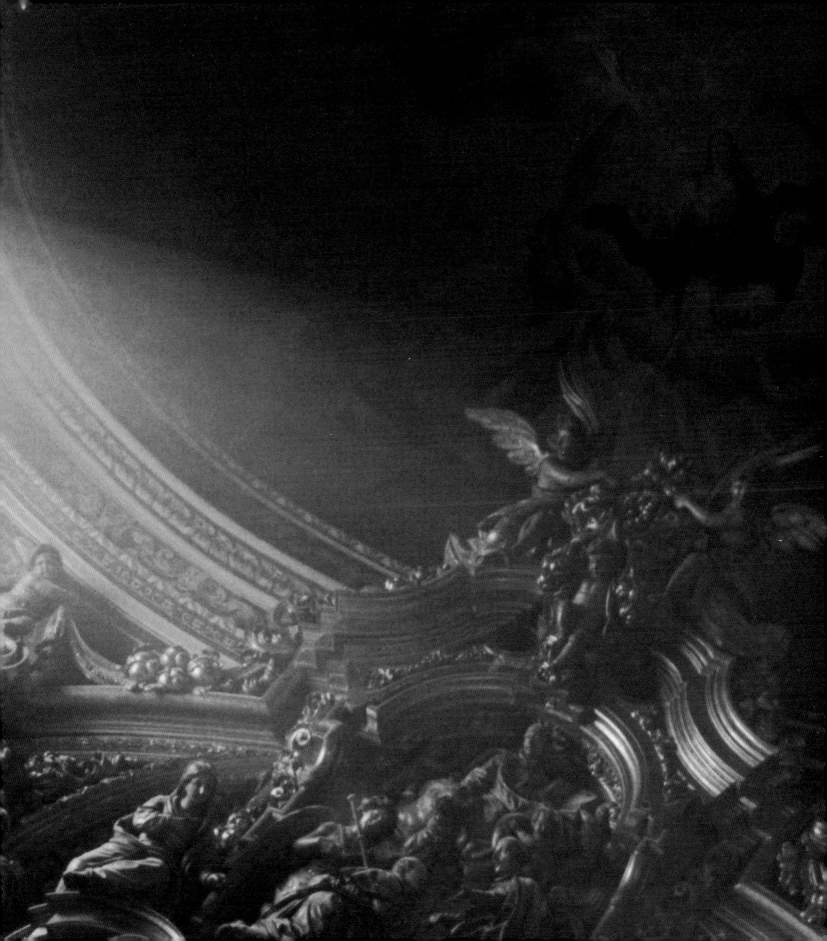

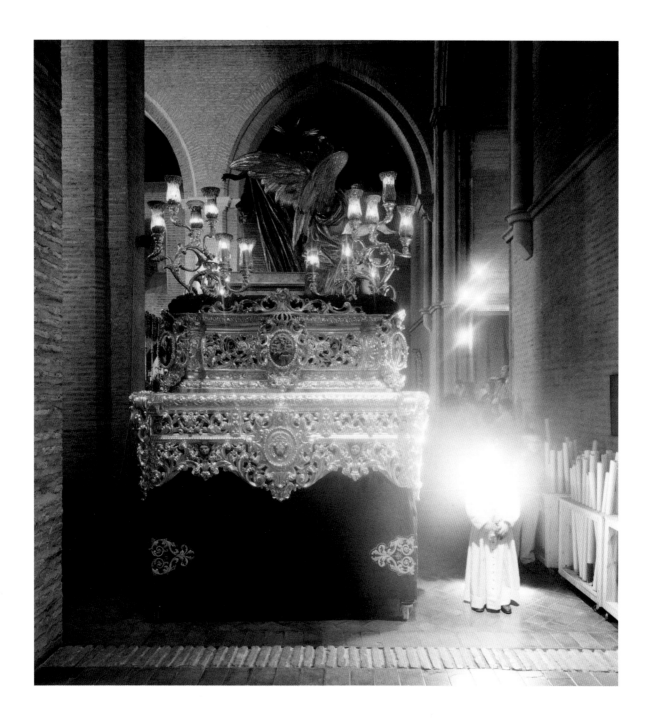

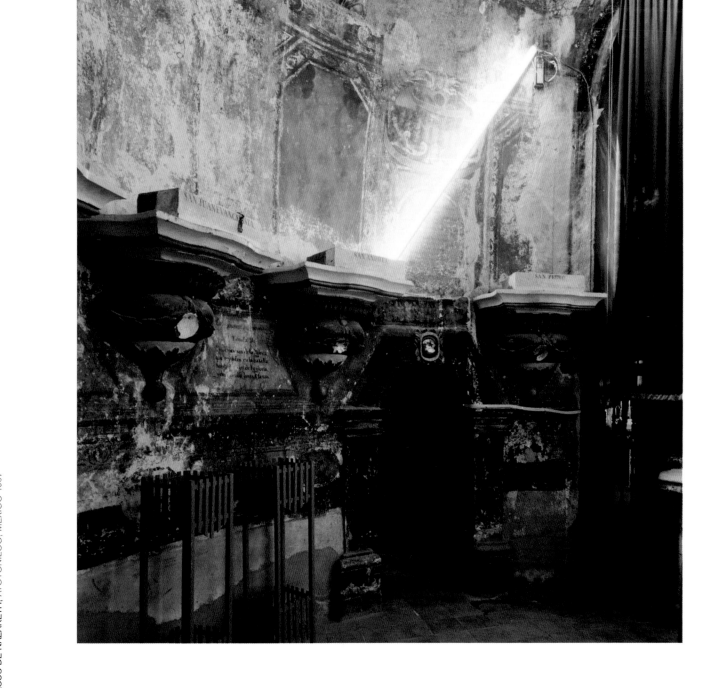

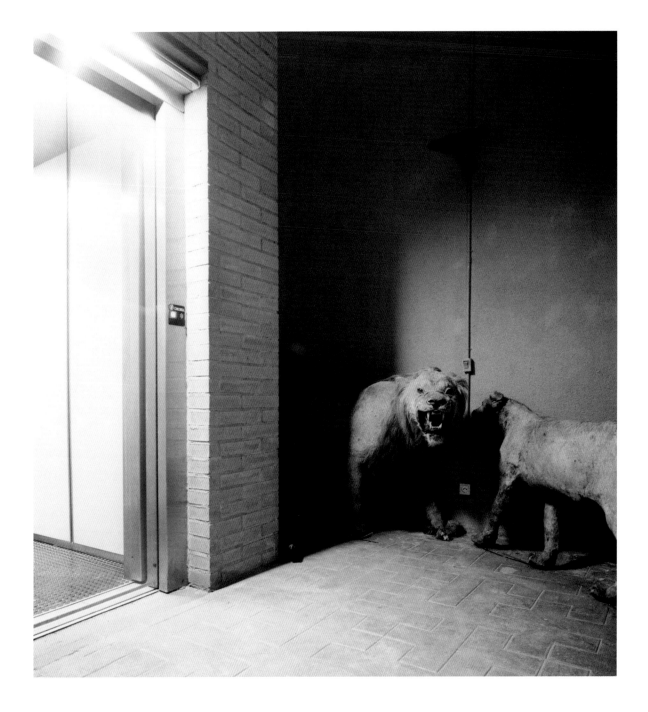

MUSEUM OF NATURAL HISTORY, BARCELONA, SPAIN 1994

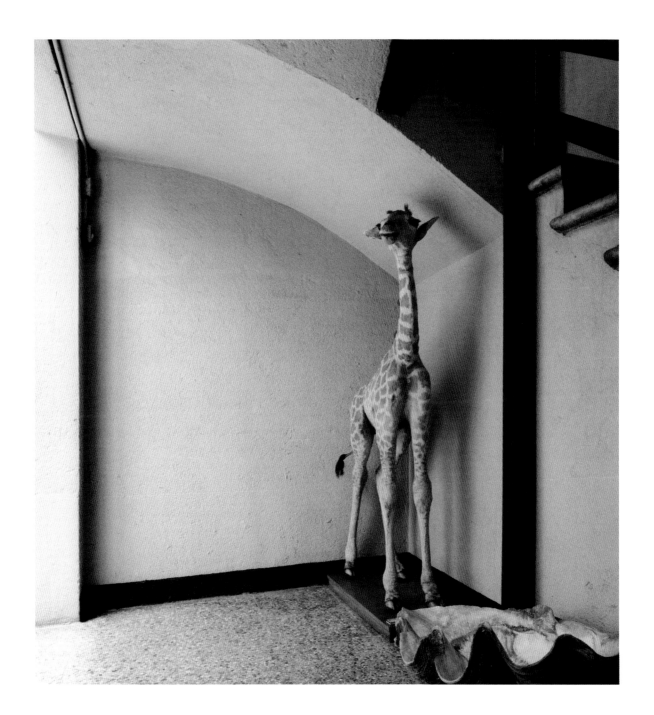

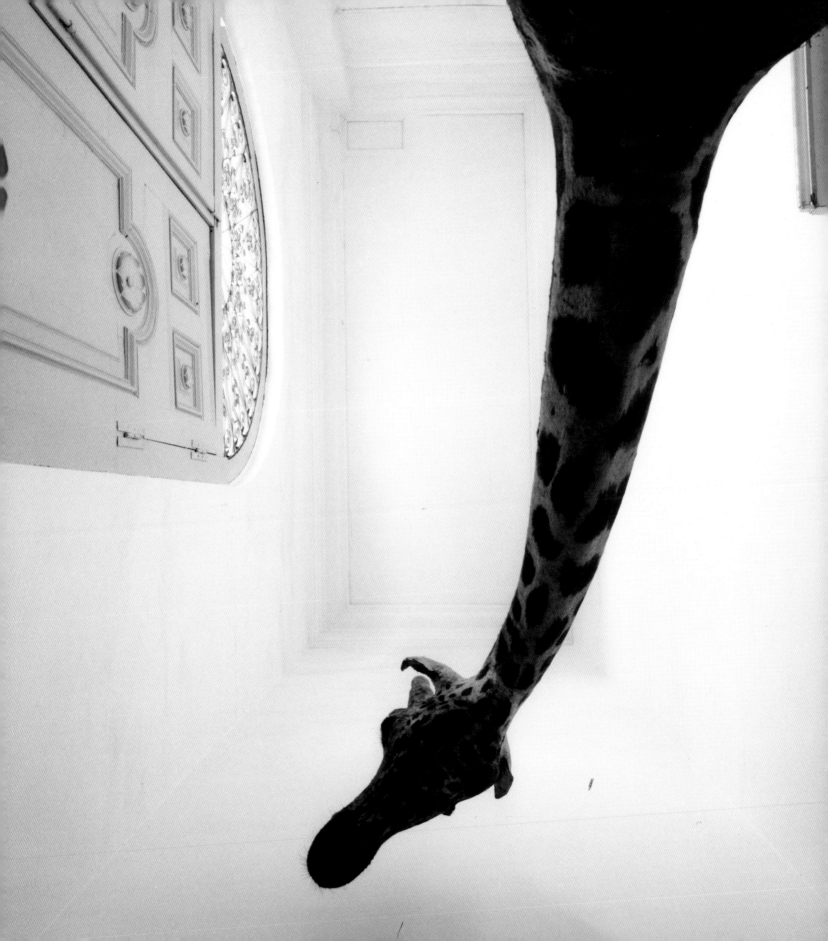

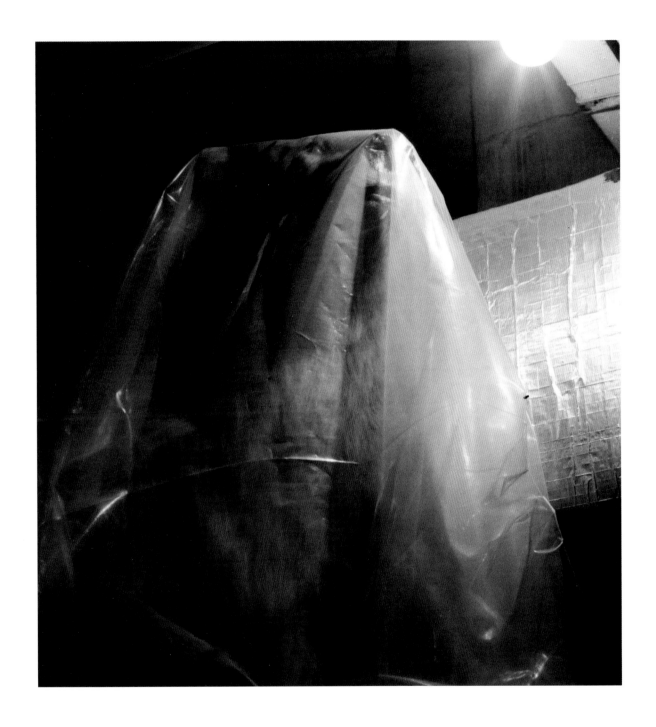

SMITHSONIAN MUSEUM ATTIC, WASHINGTON, D.C. 1993

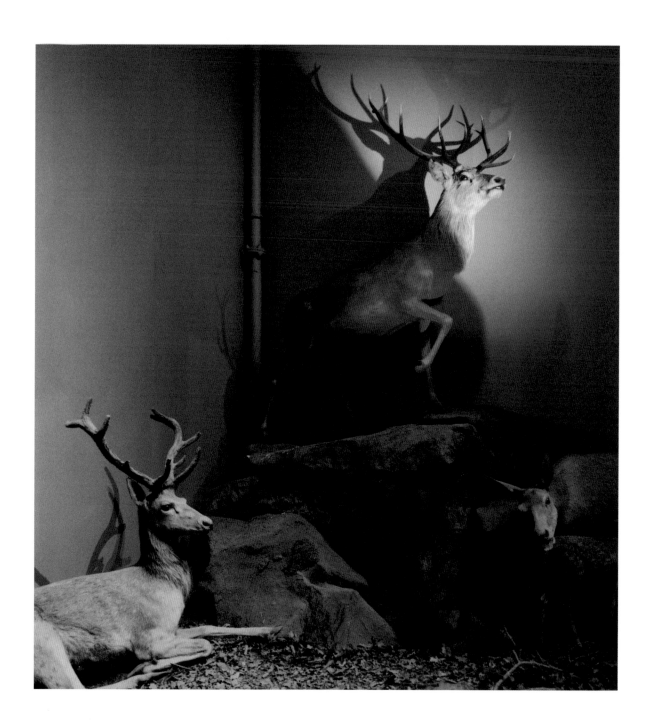

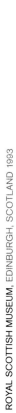

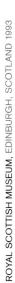

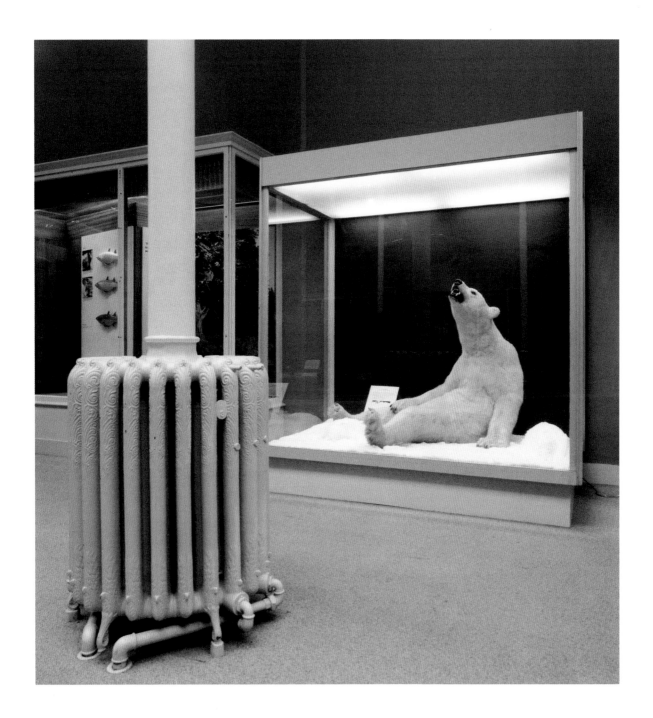

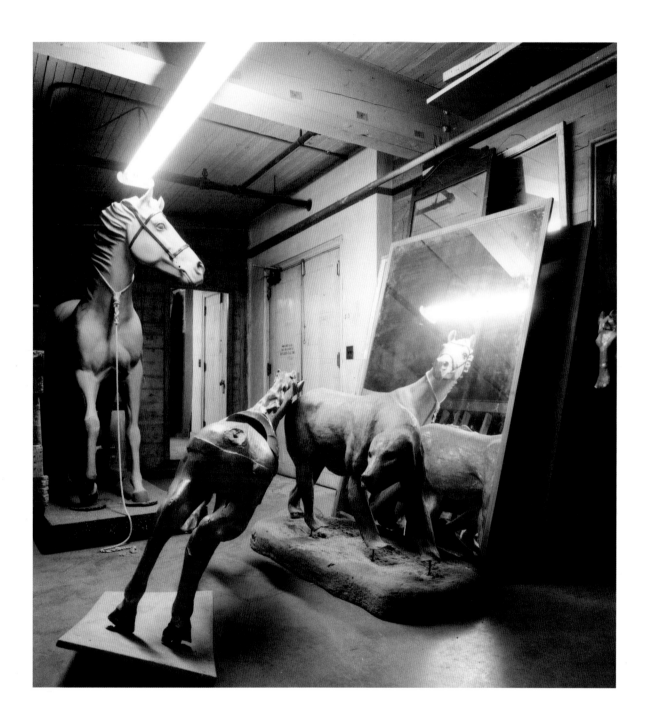

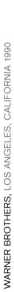

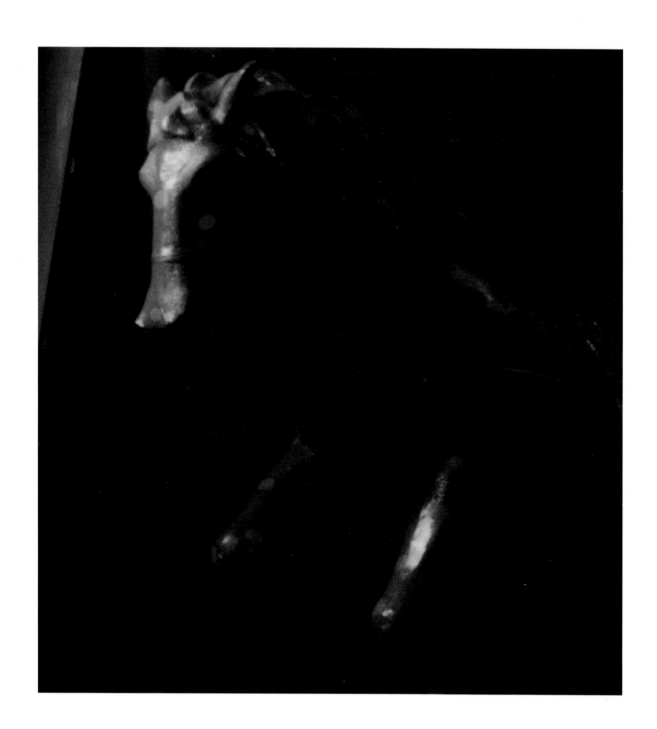

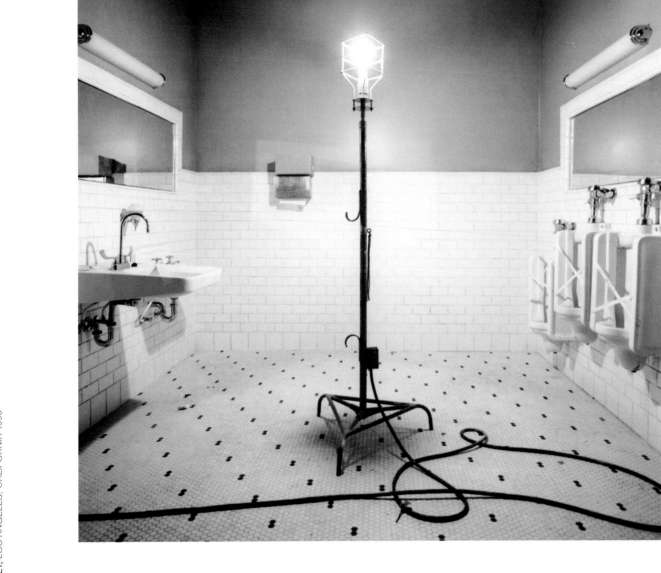

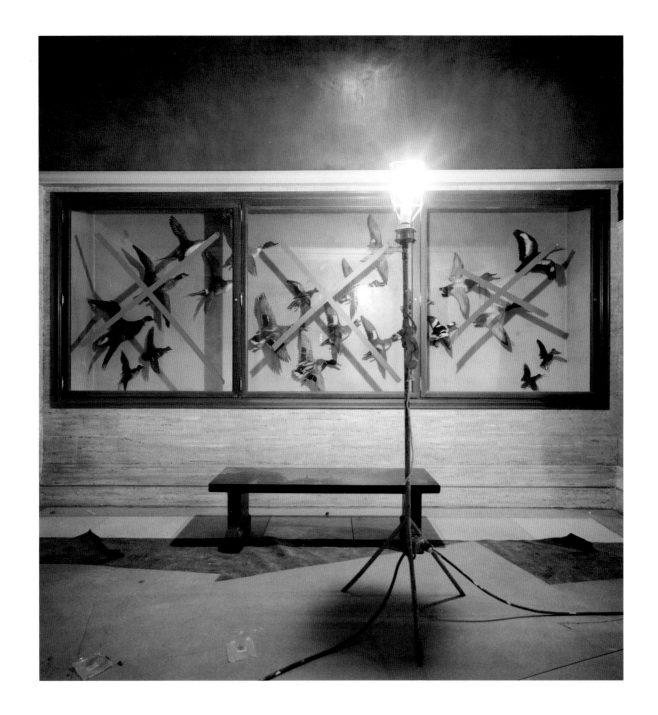

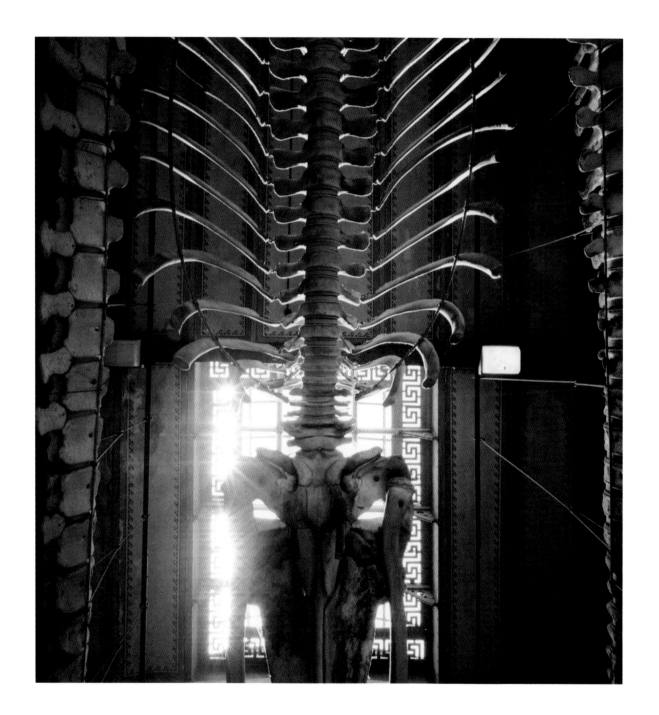

"Days die pretty much like people do, fighting for every minute of light before they give up to the dark."

CARY GRANT

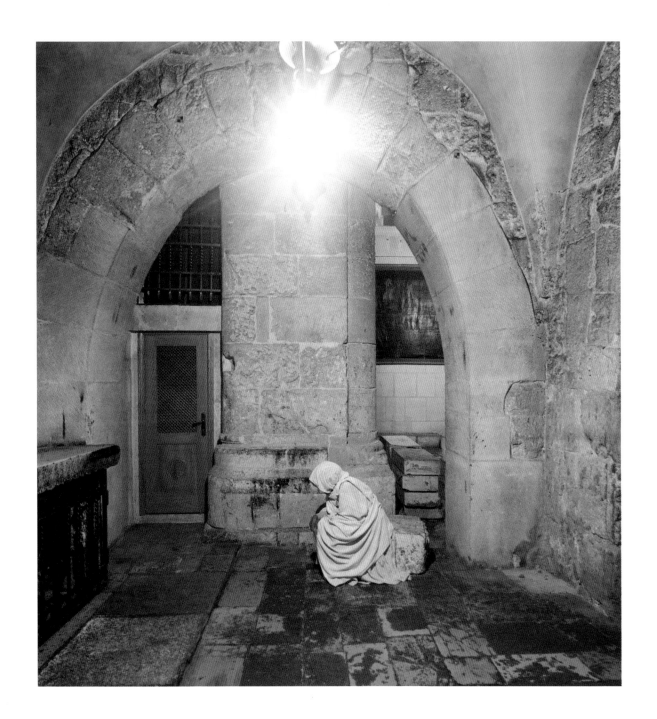

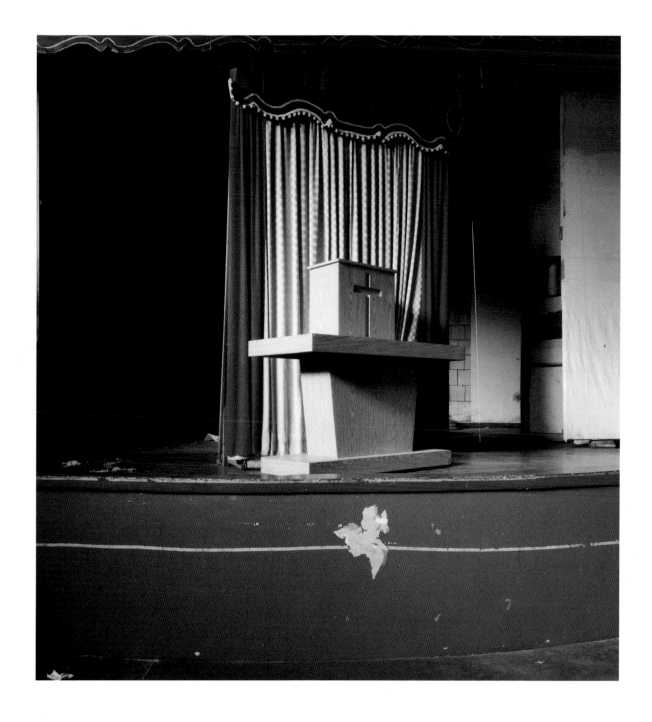

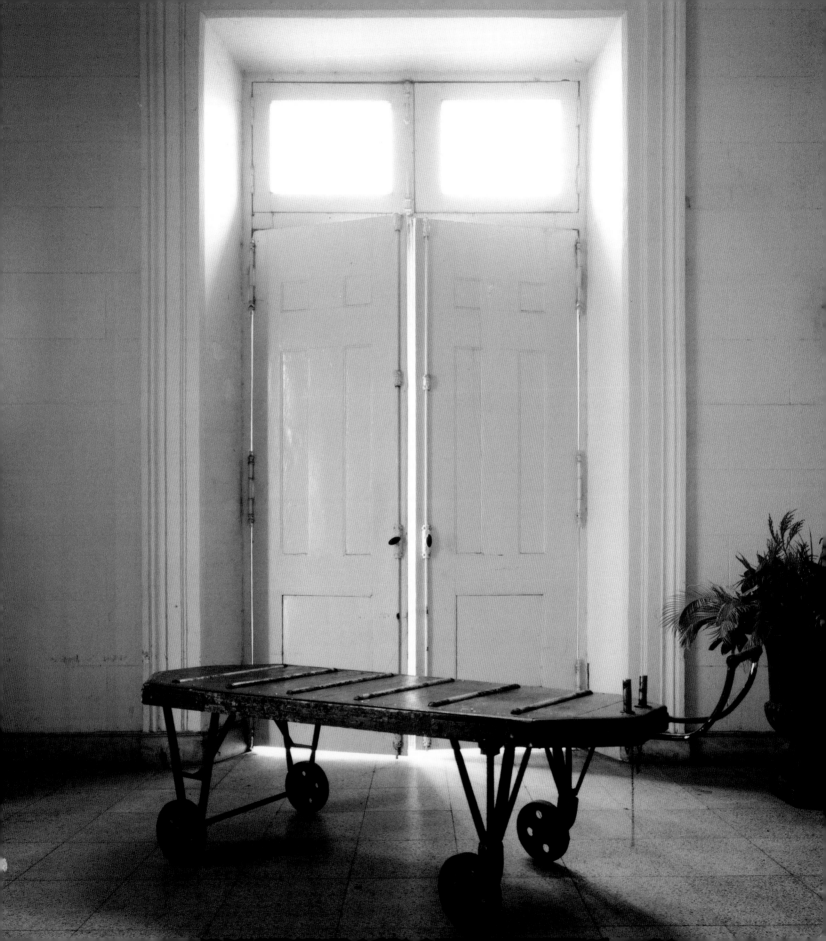

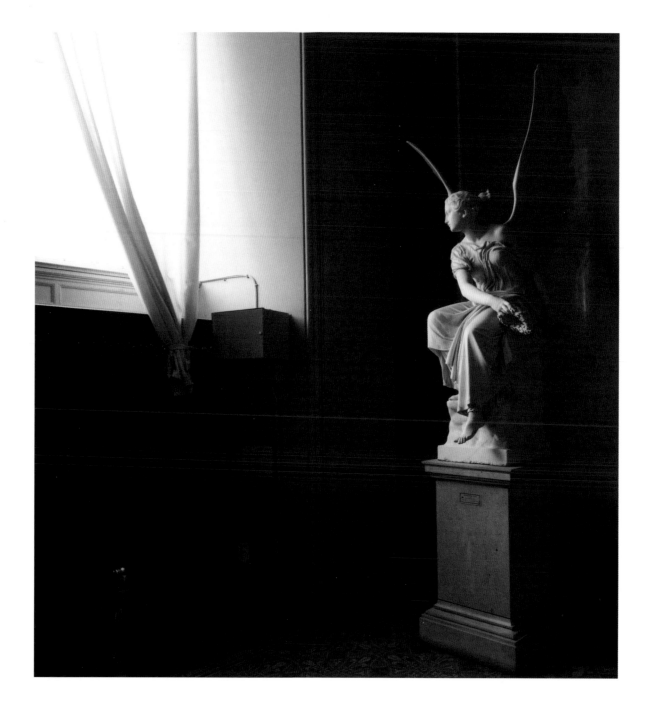

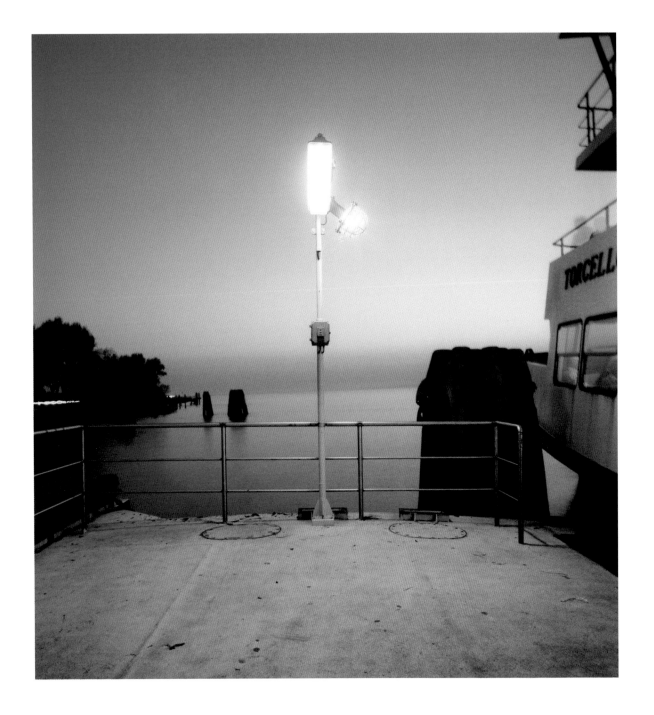

FERRY STOP, JESOLO, ITALY 1990

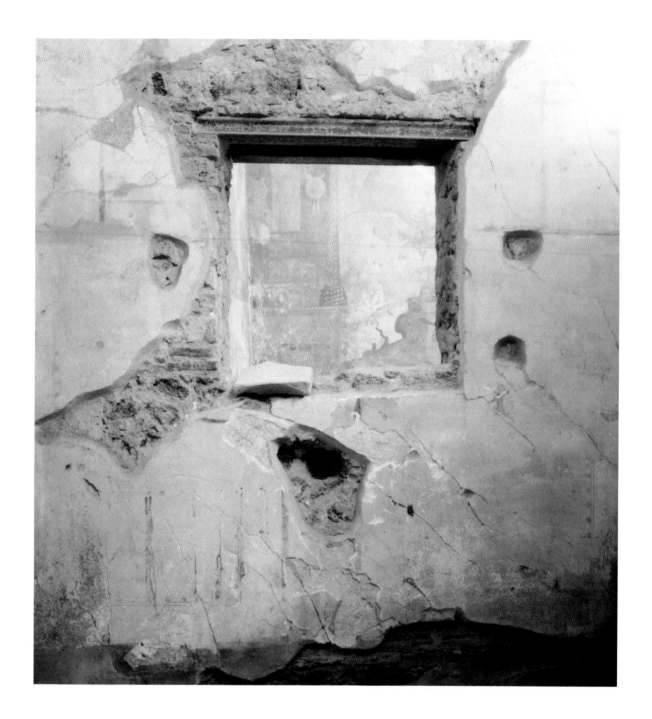

EXCAVATED ROOM, POMPEII, ITALY 1990

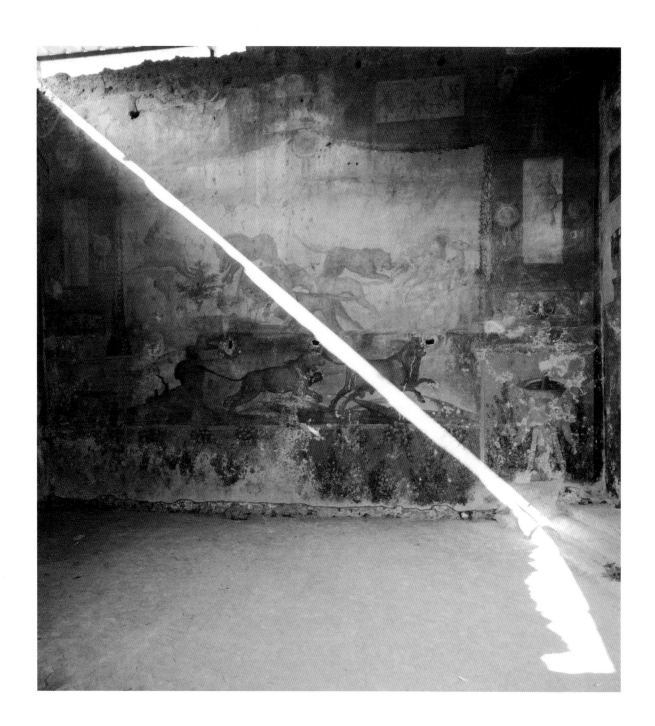

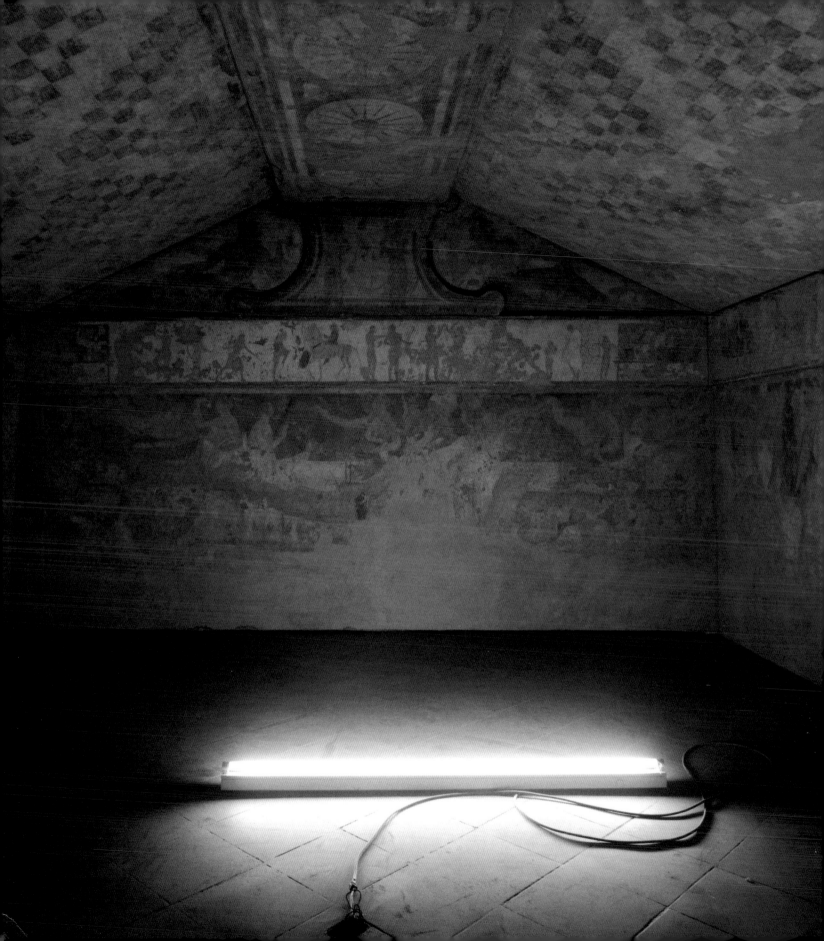

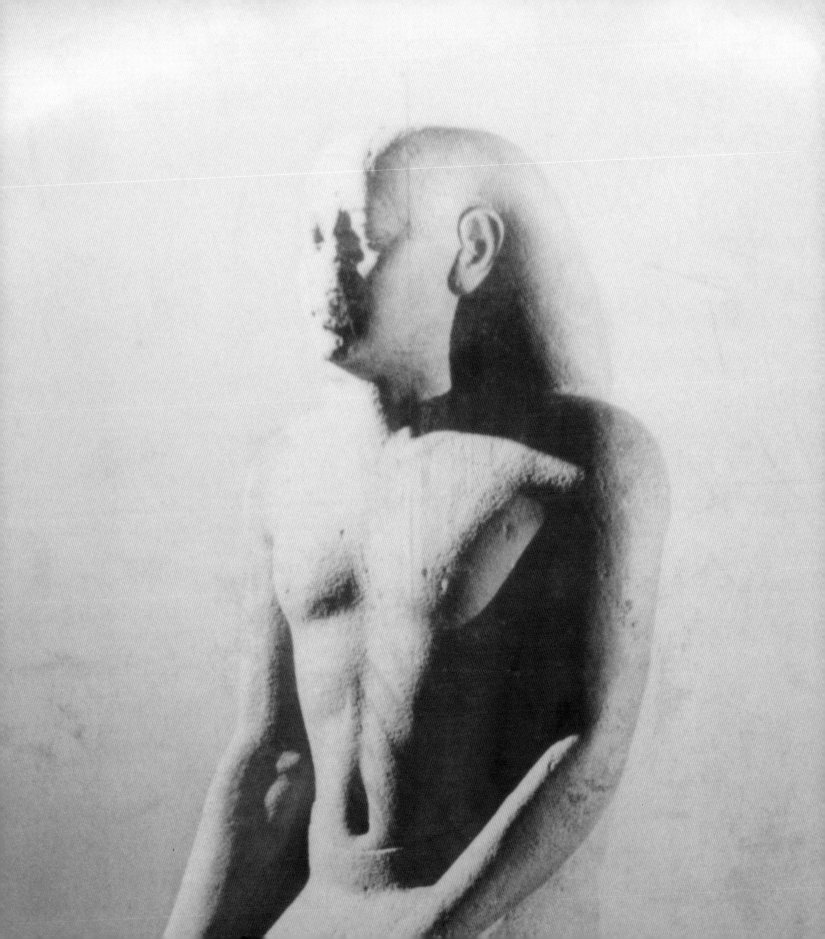

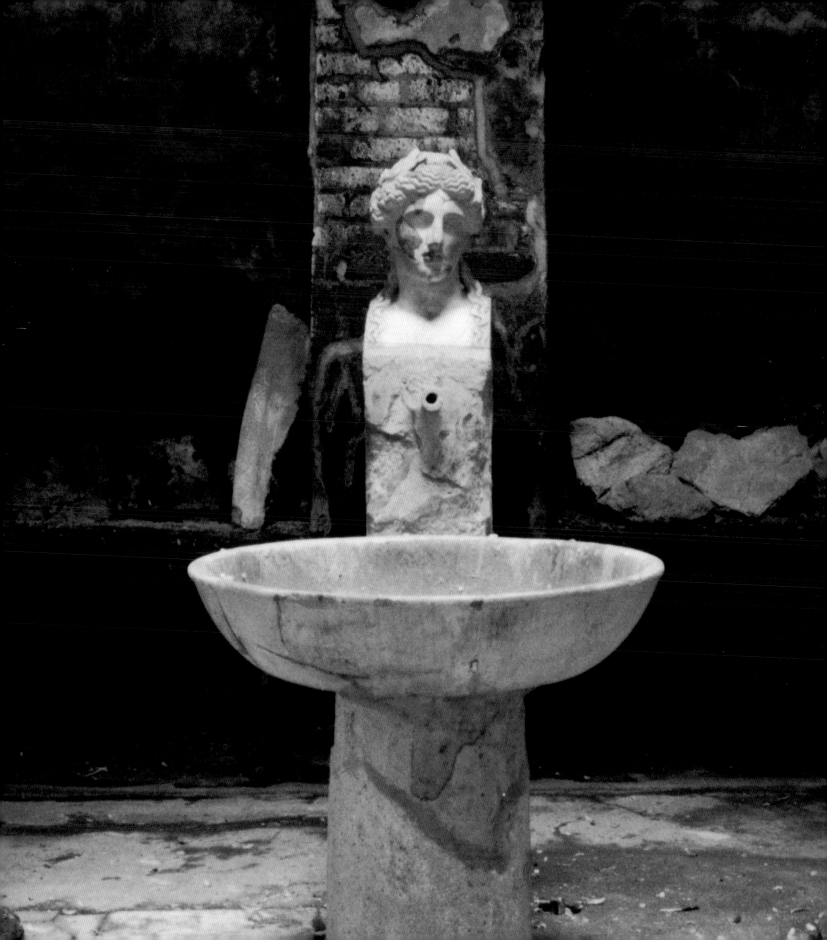

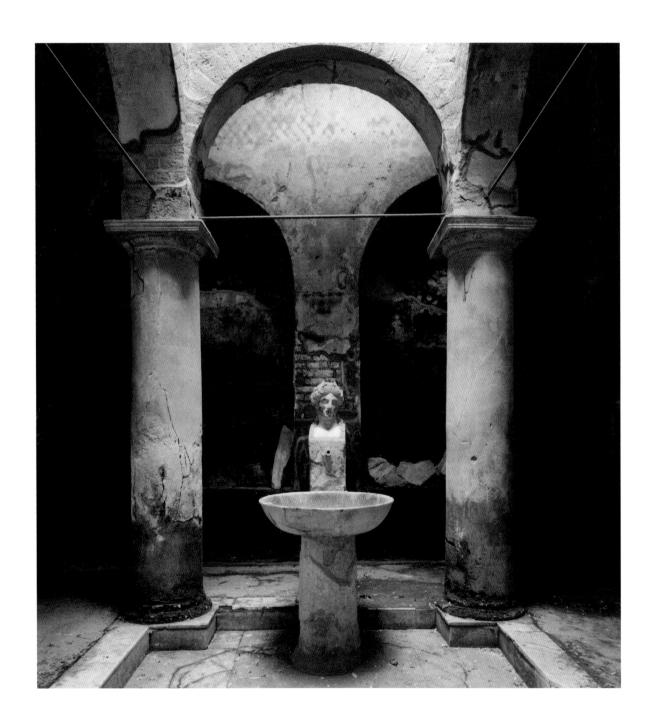

"Photons of light striking matter exert a faint pressure; the pressure of light. A person standing in direct sunlight receives the pressure from sunlight equal to about three tenths of a milligram, or the weight of an ant's thorax."

RICHARD PRESTON. FIRST LIGHT

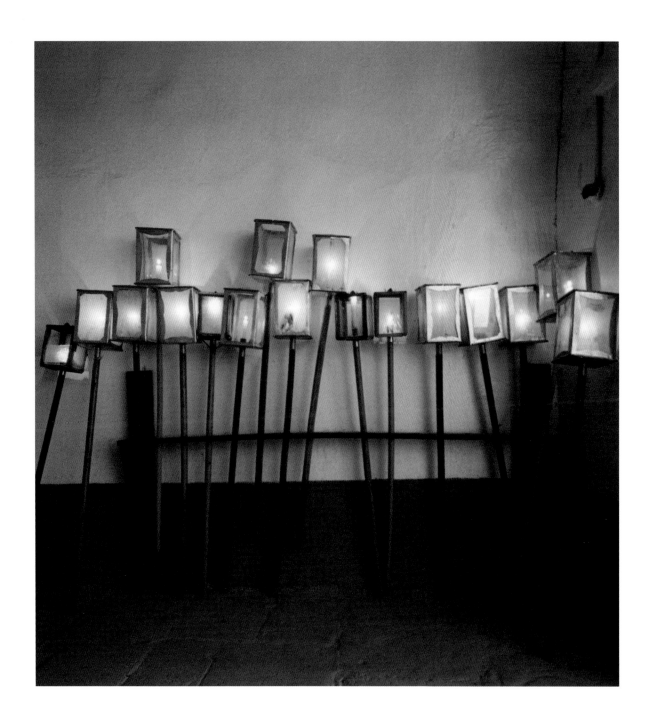

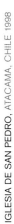

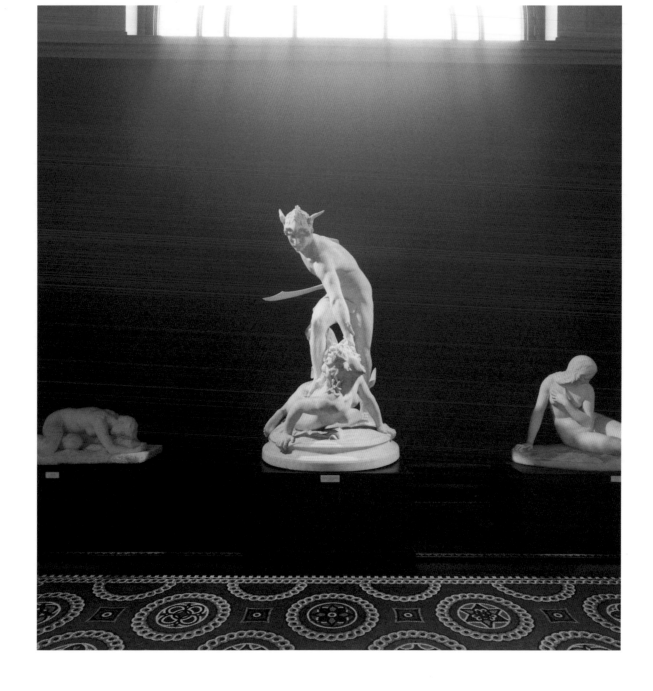

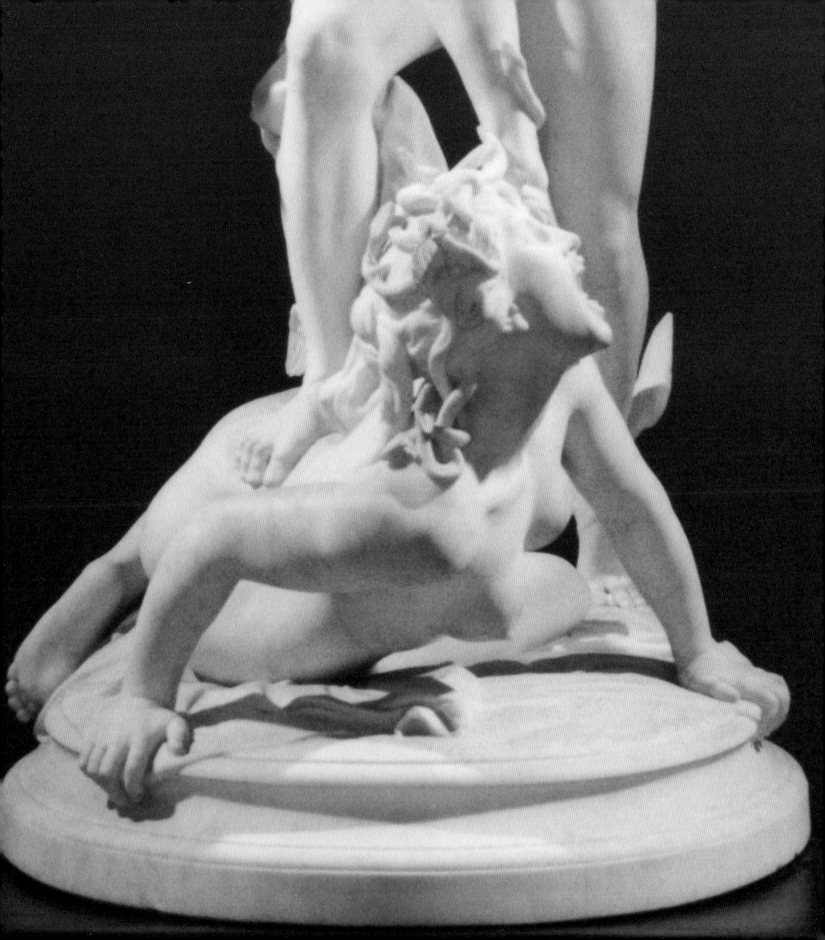

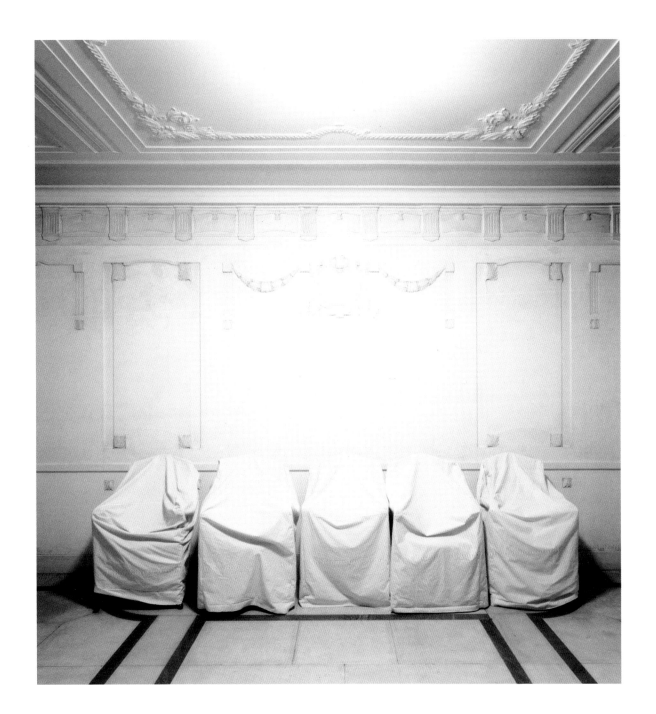

DRAMATAN, STOCKHOLM, SWEDEN 1993

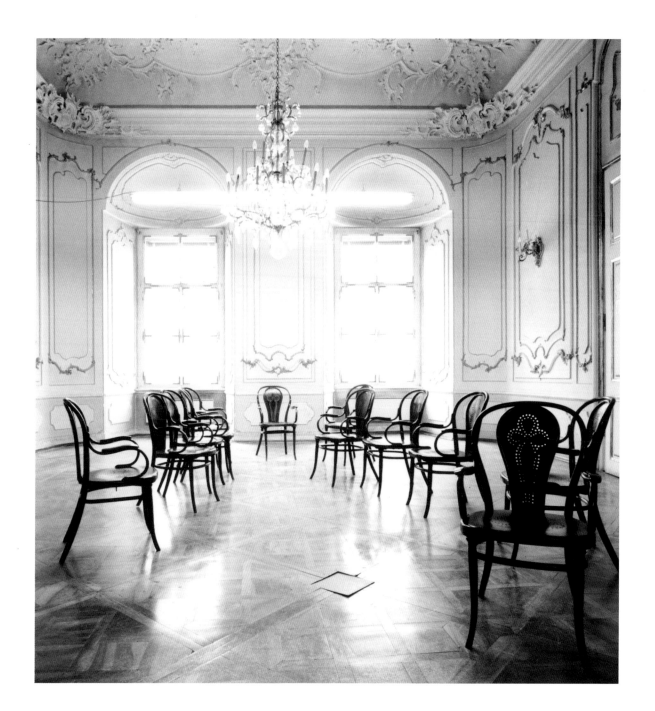

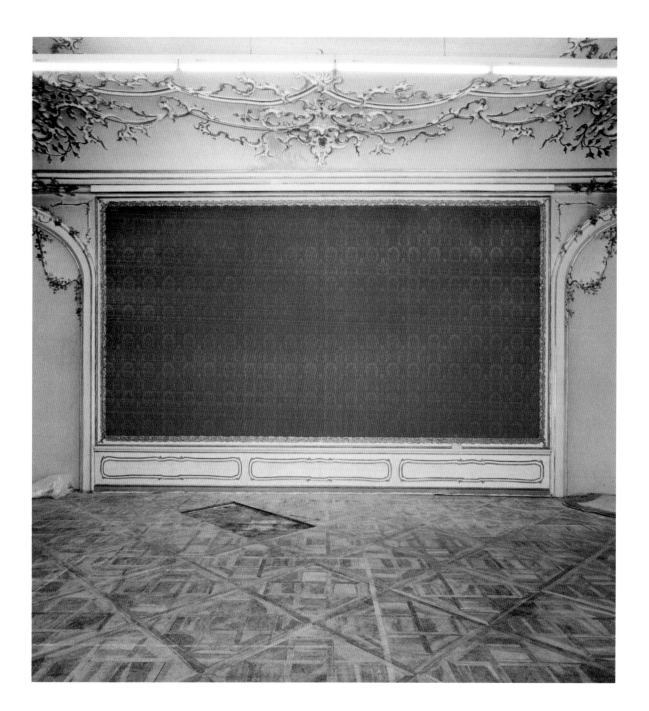

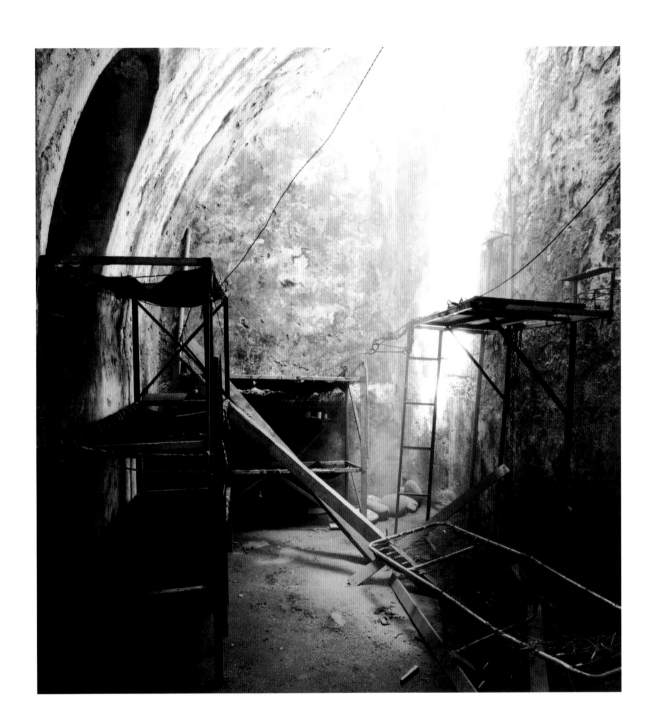

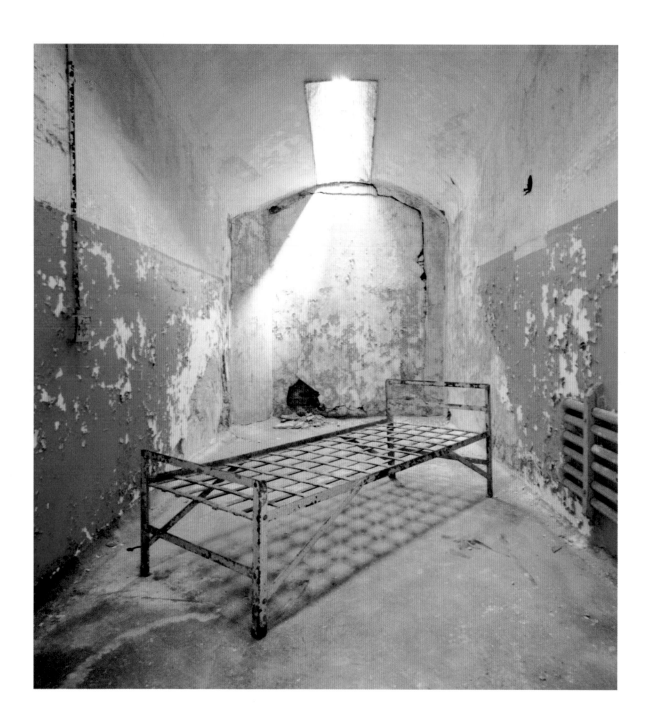

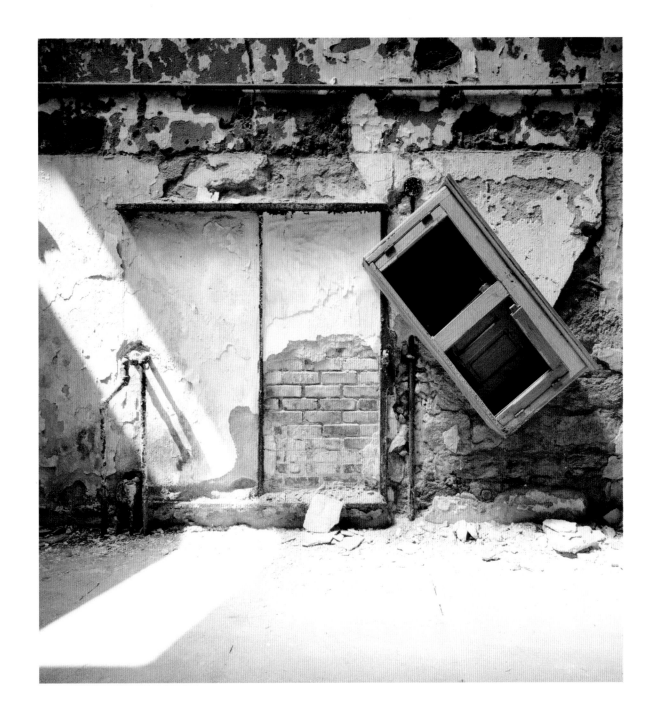

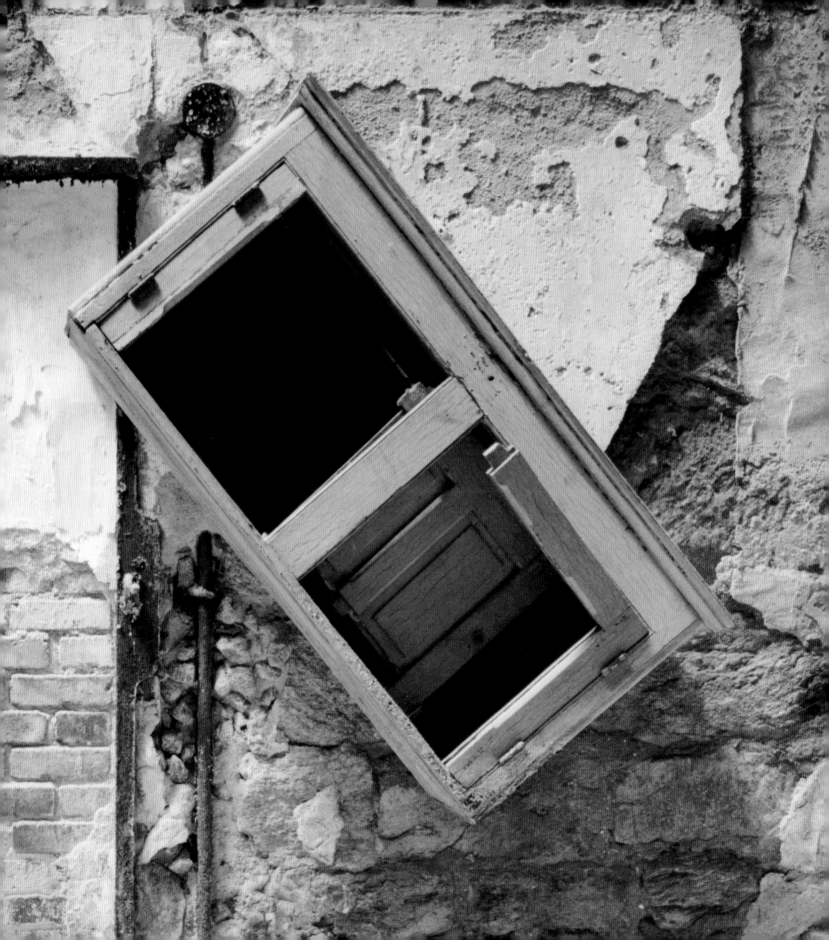

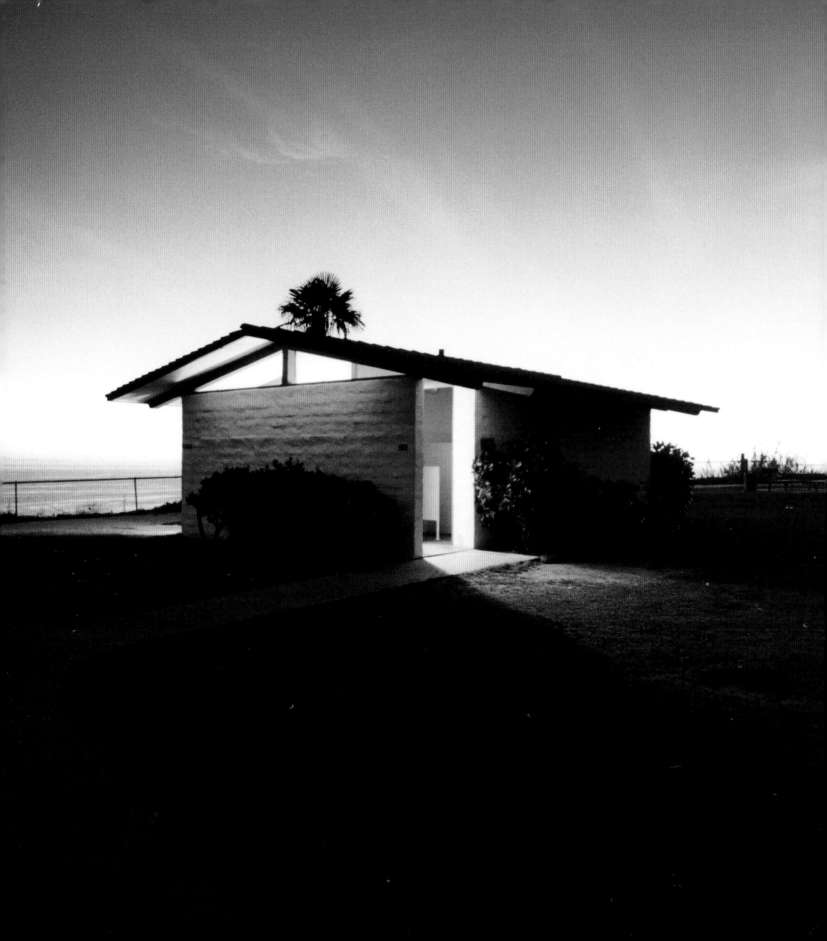

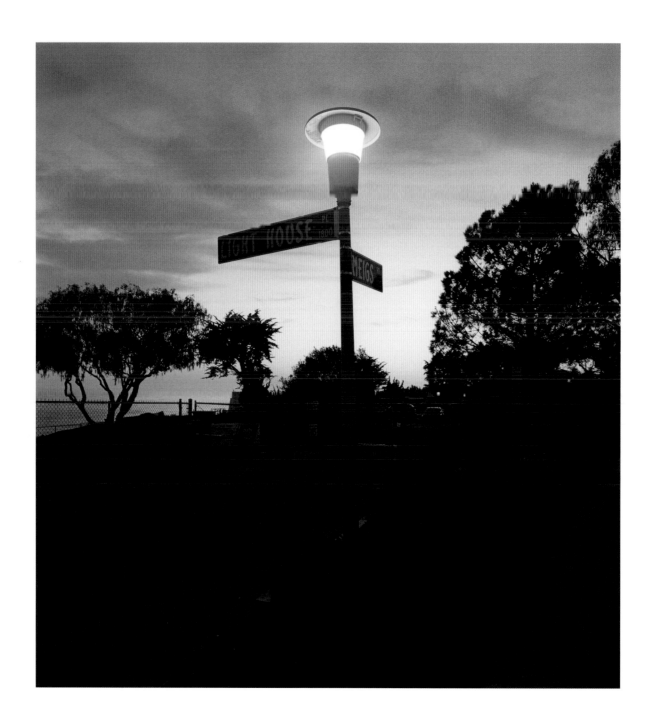

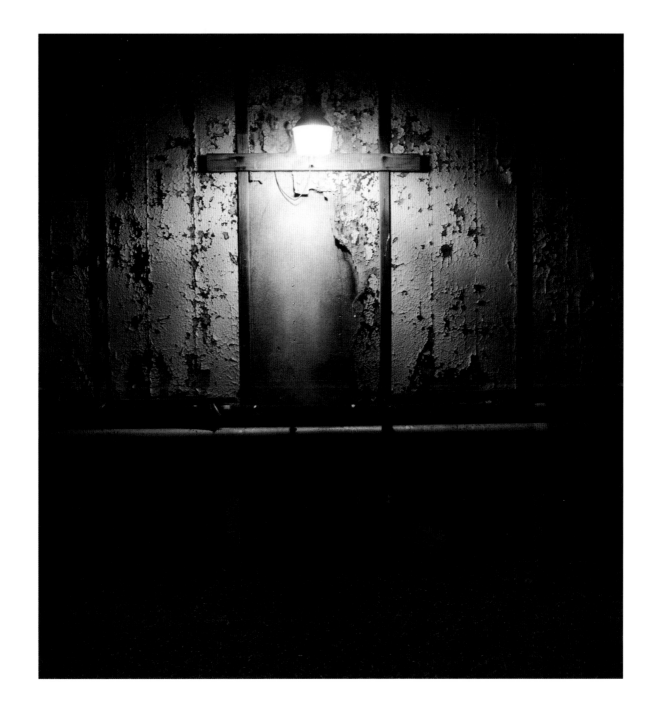

SALSIPUEDES STREET, SANTA BARBARA, CALIFORNIA 2000

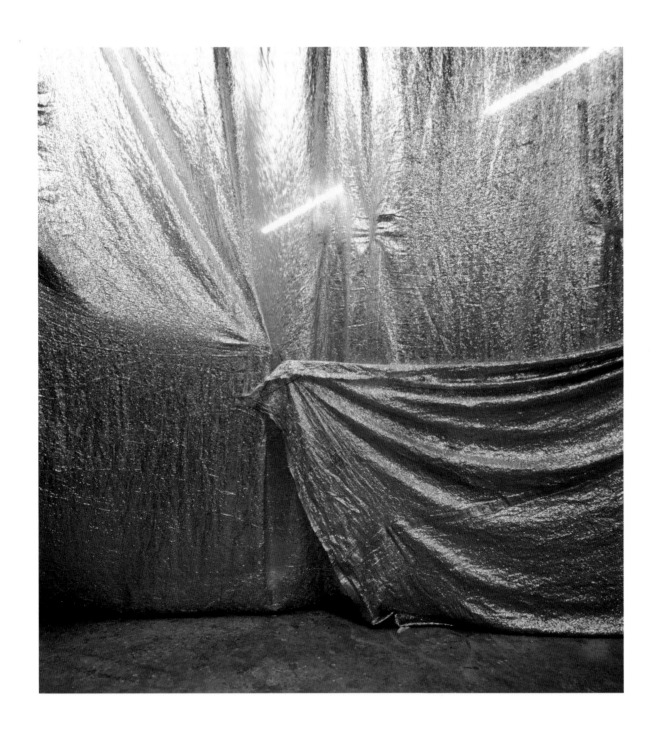

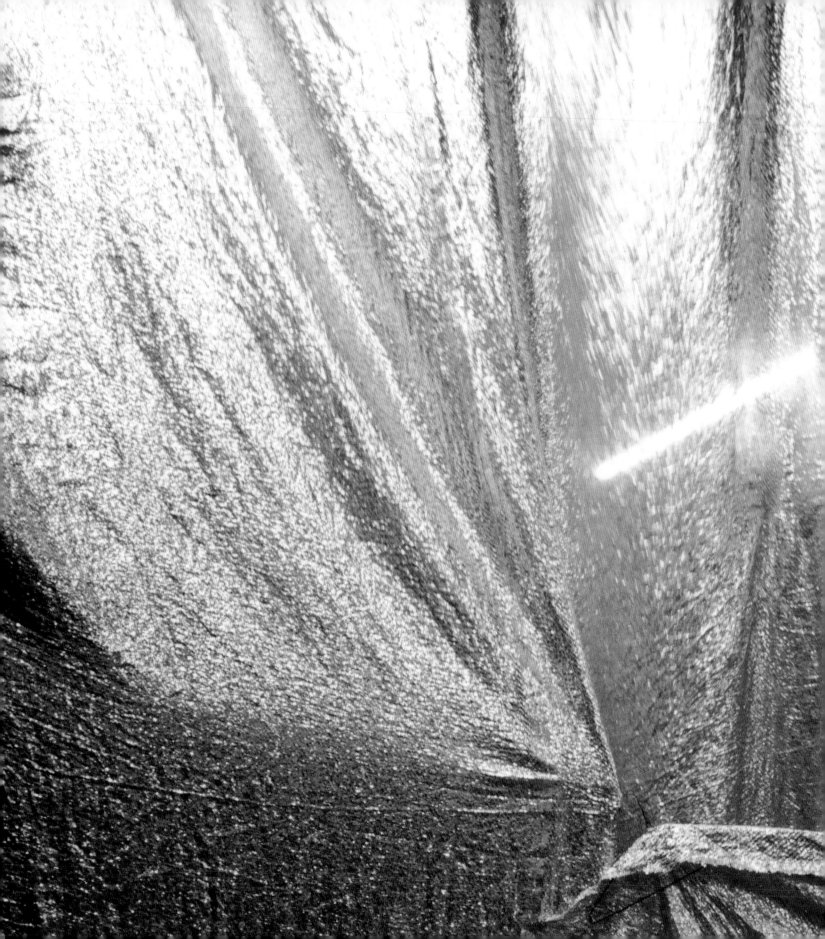

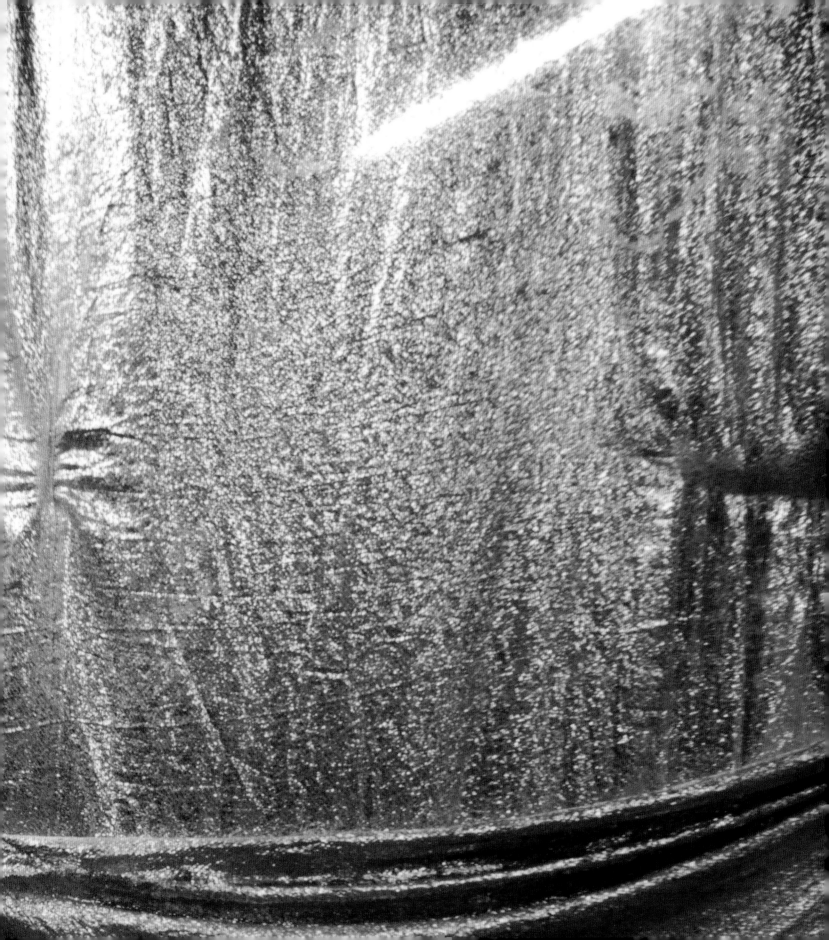

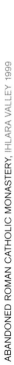

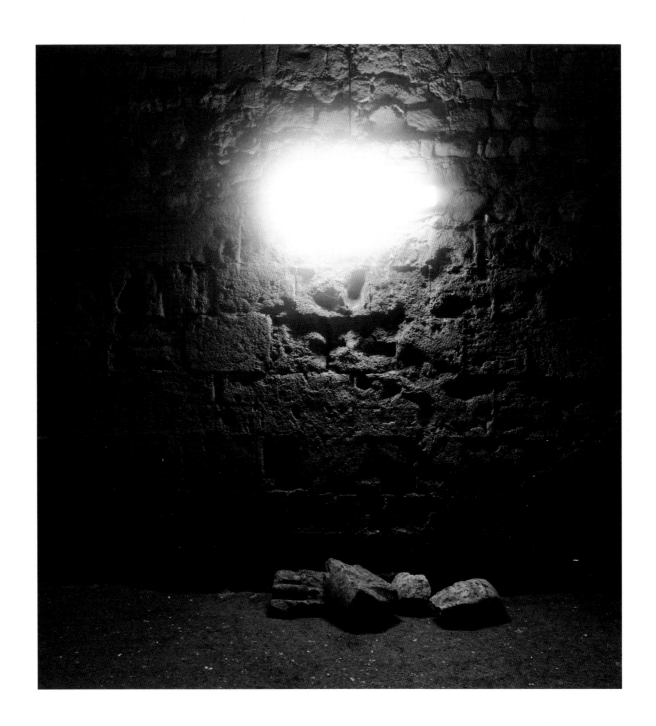

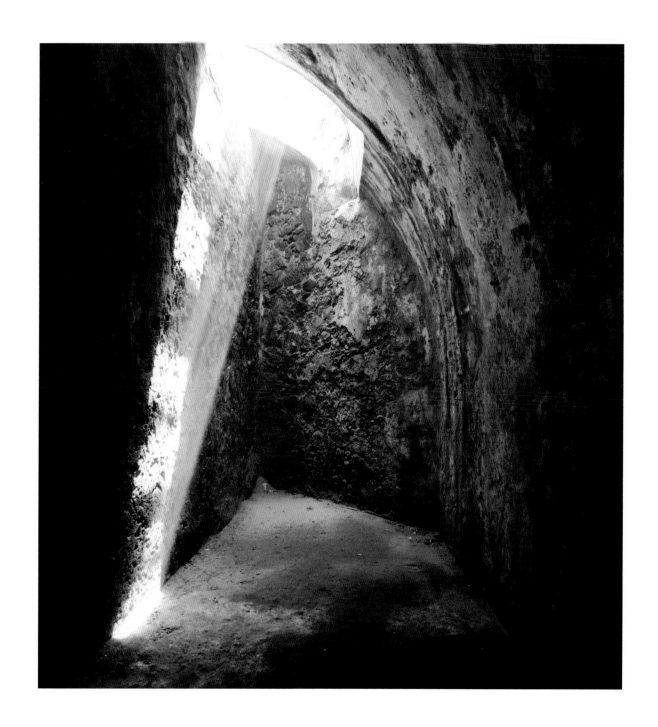

FORTELEZA SAN JUAN DE ULUA, VERA CRUZ, MEXICO 1999

FORTELEZA SAN JUAN DE ULUA, VERA CRUZ, MEXICO 1999

CARRILLO RETIREMENT HOTEL, SANTA BARBARA, CALIFORNIA 1998

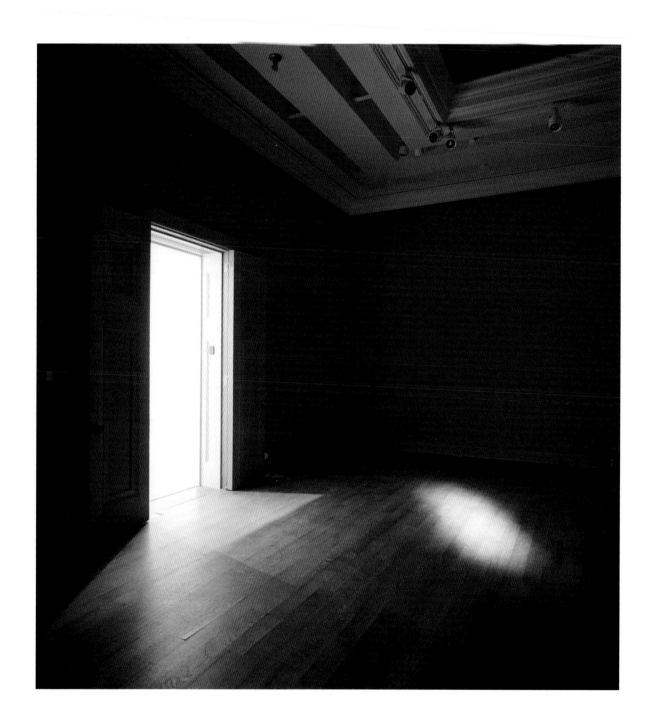

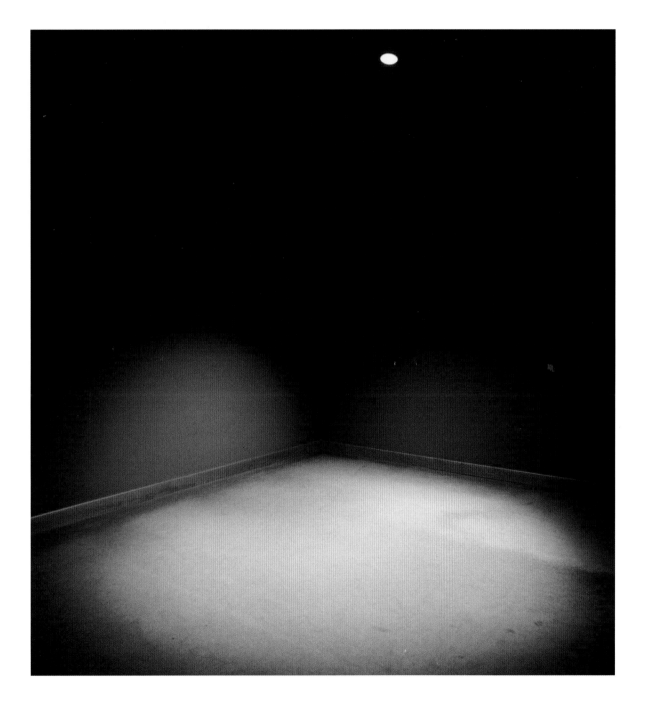

Acknowledgments

Julien Robson, curator at the Speed Art Museum in Kentucky, has been an invaluable and articulate source of critique and discussion. Robson has always offered his unequivocal support. Stephen Foster, at the John Hansard Gallery, has been interested in the work from the day he saw it—and was willing to follow his instincts. Alan Moore designed this book and gave me a skillful lesson in design, layout, and collaboration. There are also a legion of people who have shared magical places and suggested spaces that might offer visual excitement. I have been escorted to the tops of temples and the bowels of churches by people I barely knew assisting with equipment and pointing the way.

Others have opened doors, commissioned projects, collected work, carried tripods, and become close friends. I am grateful to Dieter and Gertraud Bogner, Nancy and Bruce Berman, Bonnie Earls-Solari, J.B. Jones, Rosy Fitzgerald, Jose Ramon Lopez, Ngwe Tun, Joan Tanner, Gail and Barry Berkus, Silvia Steinek, Carol Anne Klonarides, Lothar Albrecht and Meg Linton of the Santa Barbara Contemporary Arts Forum.

Grants that have supported this work have been provided by the Fulbright Foundation, Entimont Corporation, and University of California, Santa Barbara. Some travel assistance was offered by Delta and Singapore Airlines.

Special mention must be made of the efforts of assistants. I am not the most tolerant or nurturing mentor. Frequently, the assistants who were foolish enough to work with me left in rather short order. Four who remained, were dedicated and tolerant of my shortcomings, are Sky Bergman, Austin Prince, Chris Brigham and Katie Lin. Seth Cortright aided and translated in the physical production of the book.

Two assistants who have traveled with me from Burma to Italy, Morocco to Laos, Cuba to the Canary Islands are Nick Ross and Leela Ross. Without these two assistants by my side, my work and my life would have significantly less meaning.

Published by:
The John Hansard Gallery
The University
Southampton, SO17 1BJ England

The Speed Art Museum
2035 South Third Street
Louisville, Kentucky 40208 USA

Book Designed by:
Alan Moore
Joe's Garage
4 Whines Lane
Over Cambridge CB4 5PT England

Printed in Hong Kong

ISBN: 0-8263-2268-9

www.richardross.net
rross@silcom.com